討論區 024

比逛街更有活力的穿搭著色書

時尚的誕生 Coloring Book

作者：姜旻枝
翻譯：王品涵

出版者：大田出版有限公司
台北市 10445 中山北路二段 26 巷 2 號 2 樓
E-mail：titan3@ms22.hinet.net　http：//www.titan3.com.tw
編輯部專線：（02）25621383　傳真：（02）25818761
【如果您對本書或本出版公司有任何意見，歡迎來電】
行政院新聞局局版台業字第 397 號
法律顧問：陳思成 律師

總編輯：莊培園
副總編輯：蔡鳳儀
執行編輯：陳顗如
行銷企劃：張家綺、蔡依耘
美術編輯：黃寶慧
印刷：上好印刷股份有限公司‧（04）23150280
初版：2015 年（民 104）九月十日
定價：280 元

Original Korean language edition was first published in December of 2015
under the title of 패션의 탄생 : 컬러링북
(Viva! Fashion Designers - Coloring Book)
by Rubybox Publishers Co.
Copyright © 2015 Min Jee Kang
All rights reserved.
Traditional Chinese Translation Copyright © 2015 TITAN Publishing Co., Ltd.
This edition is arranged with Rubybox Publishers Co. through Pauline Kim Agency, Seoul, Korea.
No part of this publication may be reproduced, stored in a retrieval system
or transmitted in any form or by any means, mechanical, photocopying, recording,
or otherwise without a prior written permission of the Proprietor or Copyright holder.

國際書碼：978-986-179-413-6　CIP：947.45/104015272

比逛街更有活力的穿搭著色書

時尚的誕生 Coloring Book

姜旻枝◎著
王品涵◎翻譯

請替單調的時尚世界注入生氣勃勃的色彩吧！

簡單來說，可以將這本著色書視為我先前以漫畫和插畫講述現代時尚史傳奇經典的著作《時尚的誕生》和《時尚經典的誕生》（大田出版）的番外篇。

能夠藉由自己的手，親自繪製了出現於兩本書中的精緻服裝和單品，對我而言是一件很幸運的事，同時也讓我感到十分喜悅。因此，我想要透過這本著色書與更多的人分享這份喜悅。

在這本書中登場的所有服裝，全部都是實際存在的。聚集了在《時尚經典的誕生》出現過的各大傳奇設計師們所設計的服裝，以及占據現代時裝界重要地位的品牌服飾，和新一代設計師們創造的時裝，讓大家能夠親手為其上色。本書依據品牌設立的時間排序，並且替所有的服飾標註設計完成的年份與所屬的系列名稱。

雖然如何活用這本書取決於各位，我還是在此盡自己所能，提供幾個小訣竅：

▨利用網路找出所有真實存在的服裝後，依樣畫葫蘆地完成著色，或者憑藉著自己的想像力，繪製出專屬於自己風格的服裝後，再和設計師實際設計出來的顏色比較看看。

▨使用單色替沒有花紋的衣服上色當然很好，不過也可以試著自己替衣服創造花紋，沒有非得執著於按照圖畫線條的必要。盡情發揮創意，替服飾增添新穎的設計。替書中服裝上色的同時，各位等於就是擔任各大品牌的設計師。

▨試著替書中人物的臉孔上妝，畫畫睫毛、腮紅以及唇彩。

▨最不可或缺的工具就是彩色鉛筆了。依據使用水性色鉛筆或油性色鉛筆，能讓作品在完成後出現不同的感覺。如果想要呈現素淡、朦朧的感覺，可以選用水性色鉛筆；如果想要呈現鮮明、濃烈的感覺，可以選用油性色鉛筆。除了色鉛筆之外，也可以利用麥克筆、顏料、墨水、簽字筆、粉筆、蠟筆等，選擇適合自己的材料進行著色，便能完成與眾不同的獨有作品。

收錄於本書的圖畫，有部分是將先前已經完成的圖畫重新製作而成。此外，可以在我的網站(www.kangminjee.com)看到完成上色的插畫作品，然後試著和自己的著色畫比較一下，想必也會是件饒富趣味的事。

雖然最近市面上出版了各式各樣的著色書，不過我真的傾注了極大的努力，讓這本書去蕪存菁地成為最能忠實呈現時尚經典的著色書。希望能夠讓夢想著成為時尚設計師的各位，抑或是走在別條道路上卻熱愛時尚的各位，在替本書上色的當下，體會到身為設計師的喜悅。

2015年3月 姜旻枝

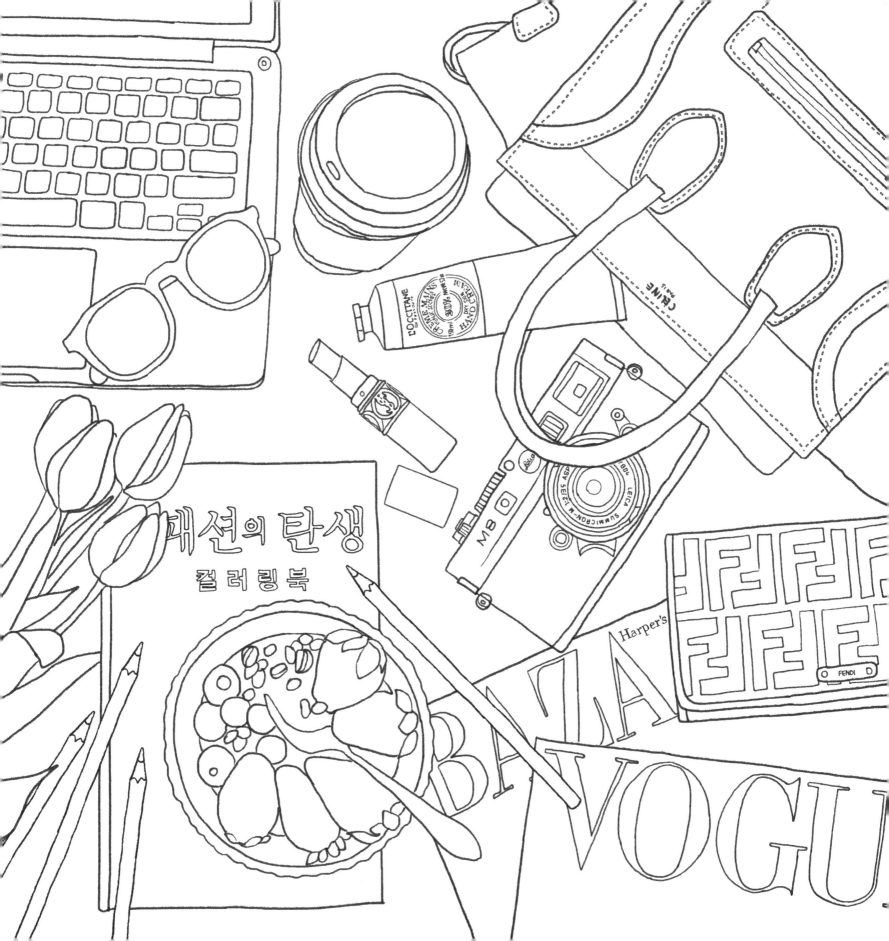

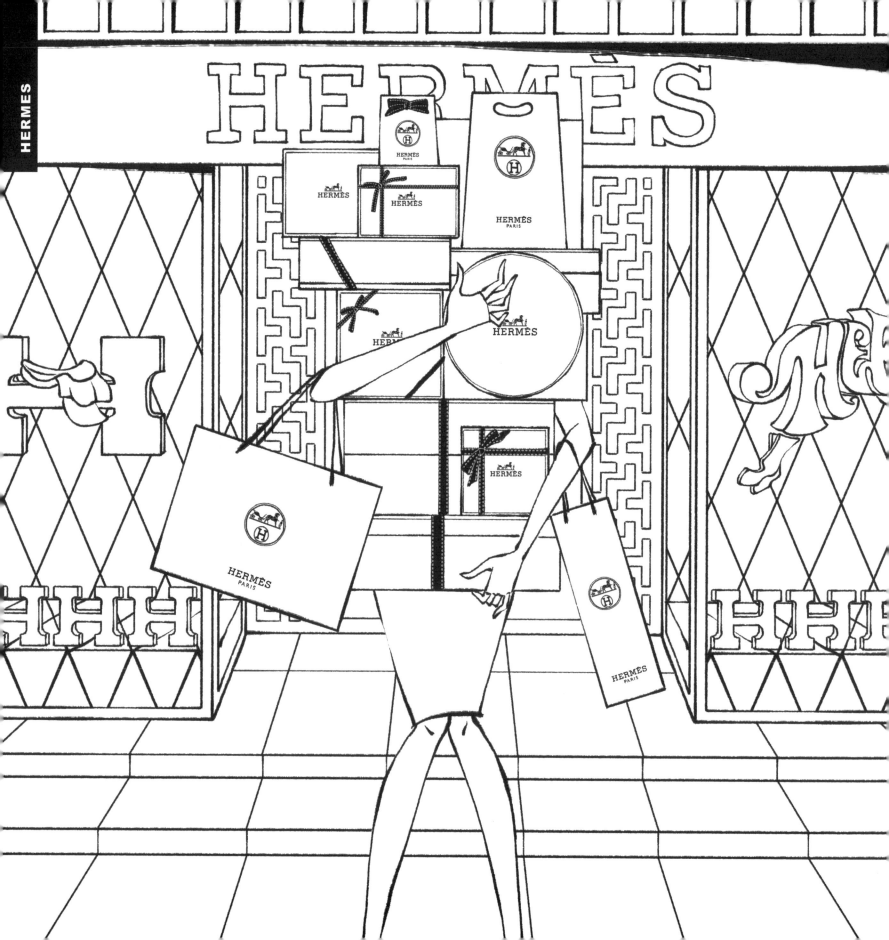

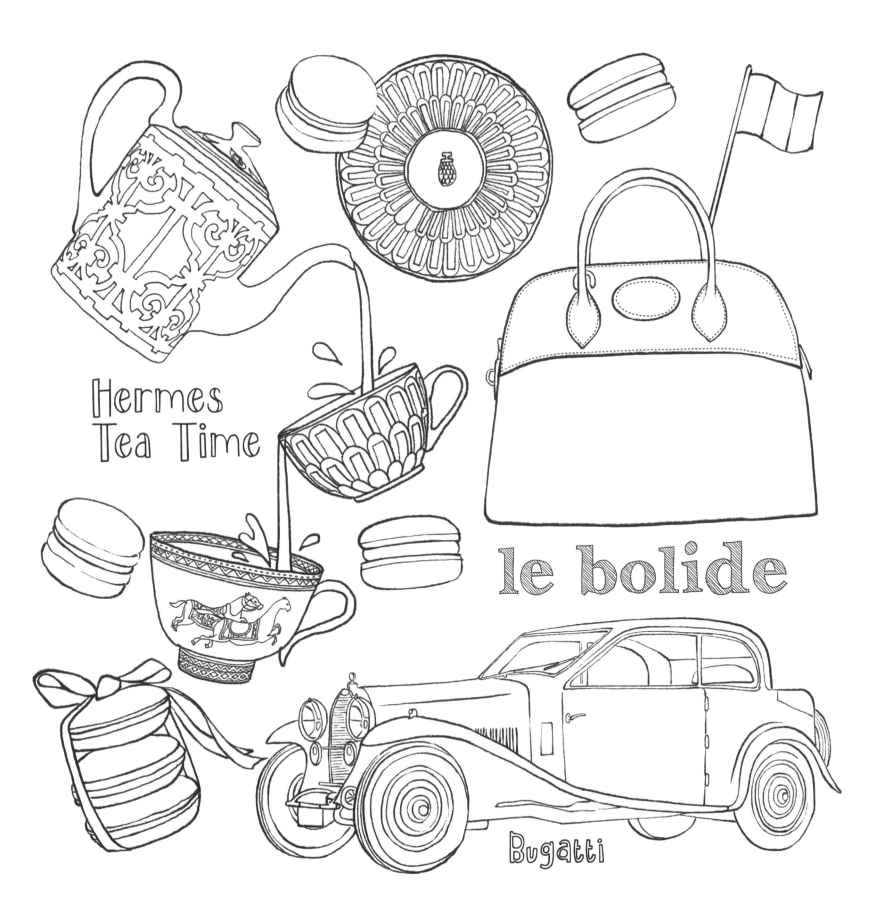

Hermes
Tea Time

le bolide

Bugatti

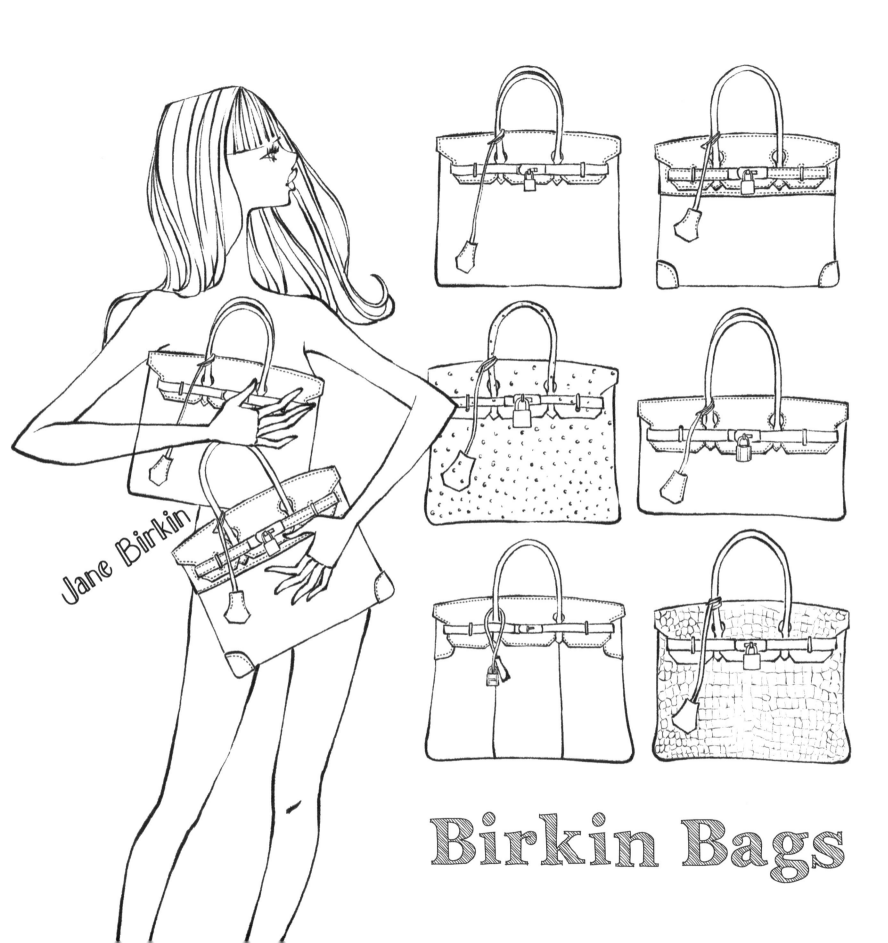

Jane Birkin

Birkin Bags

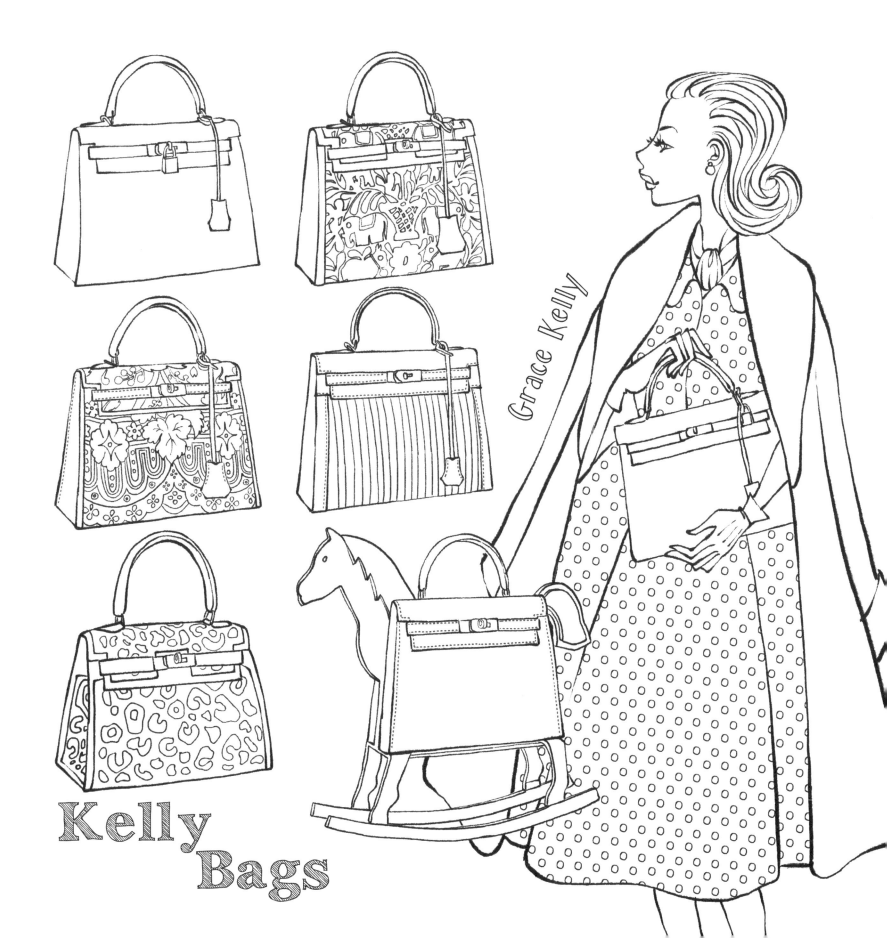

Grace Kelly

Kelly
Bags

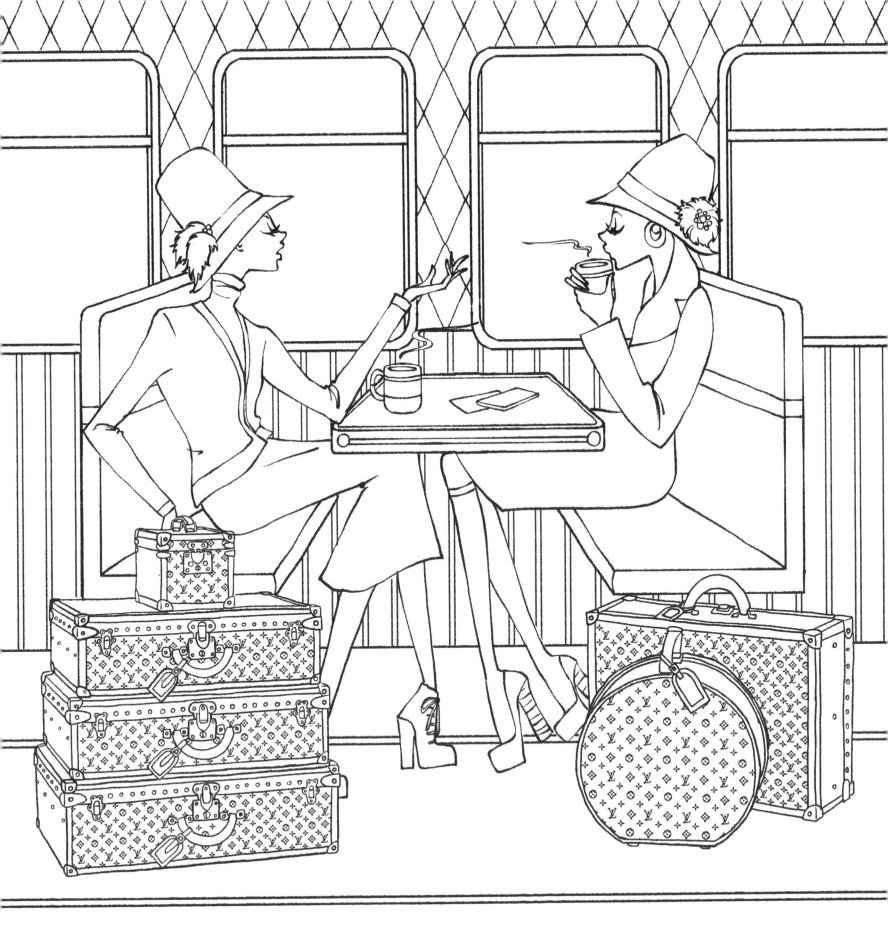

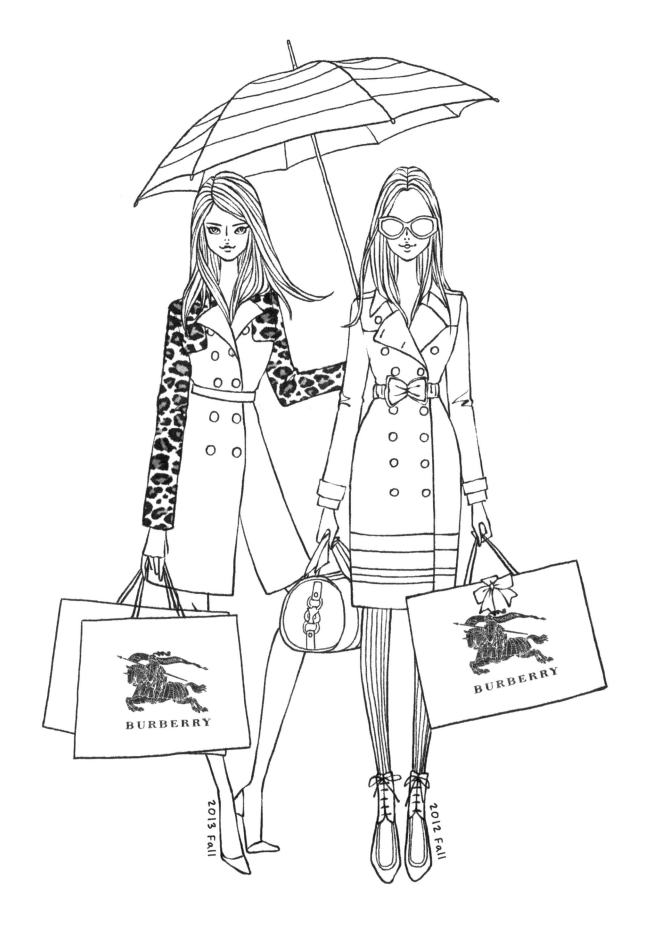

2013 Fall

2012 Fall

2013 spring

2011 Fall

2012 spring

2011 spring

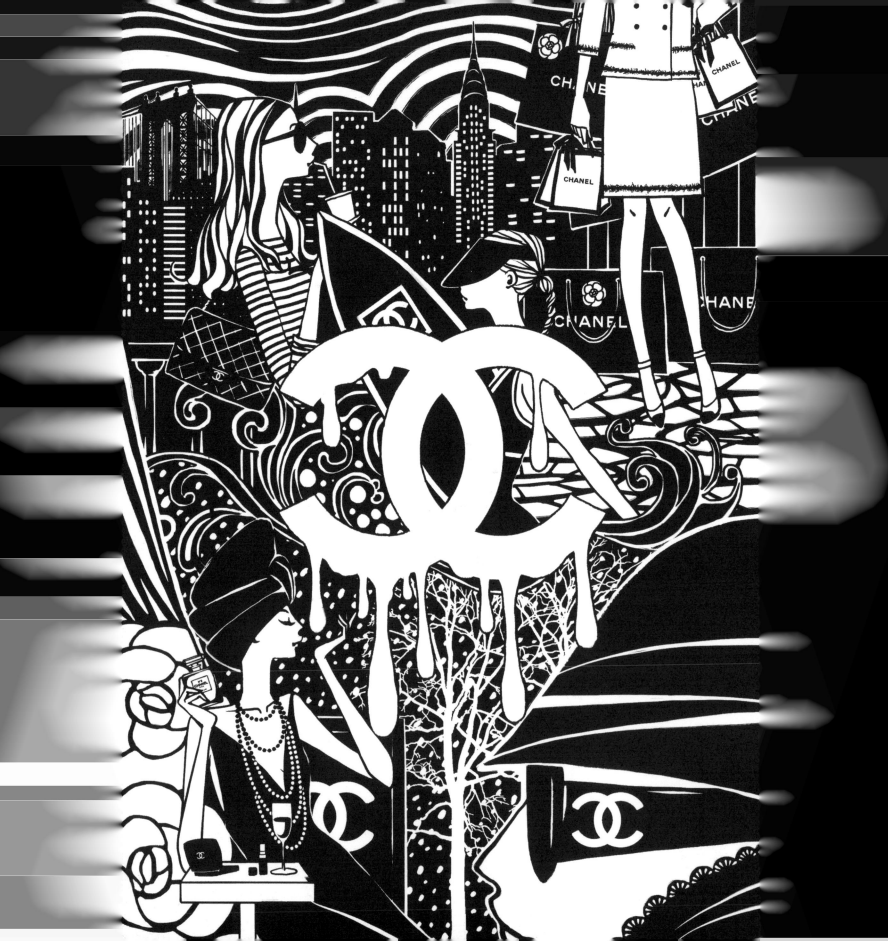

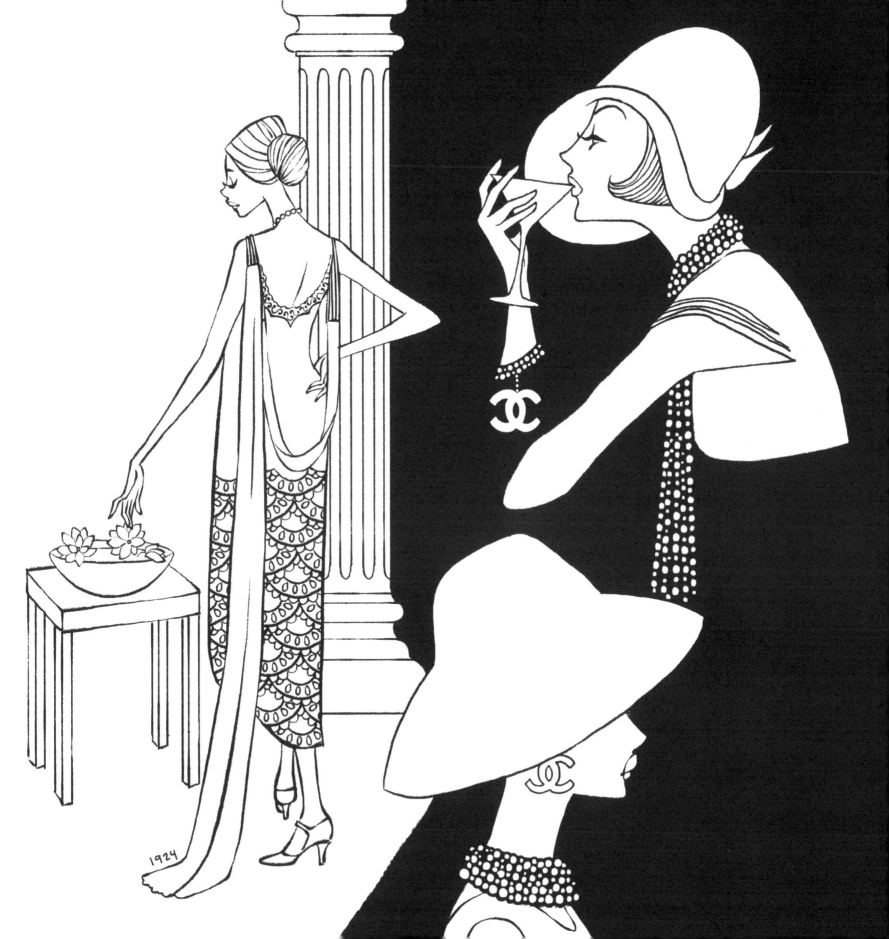

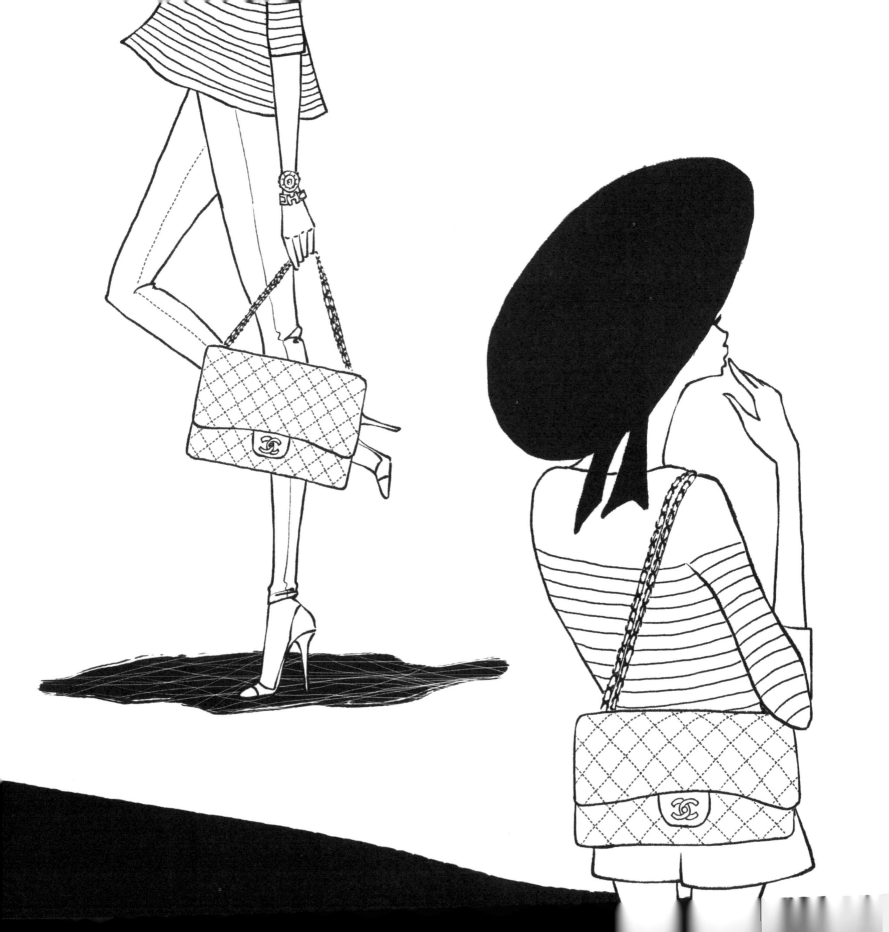

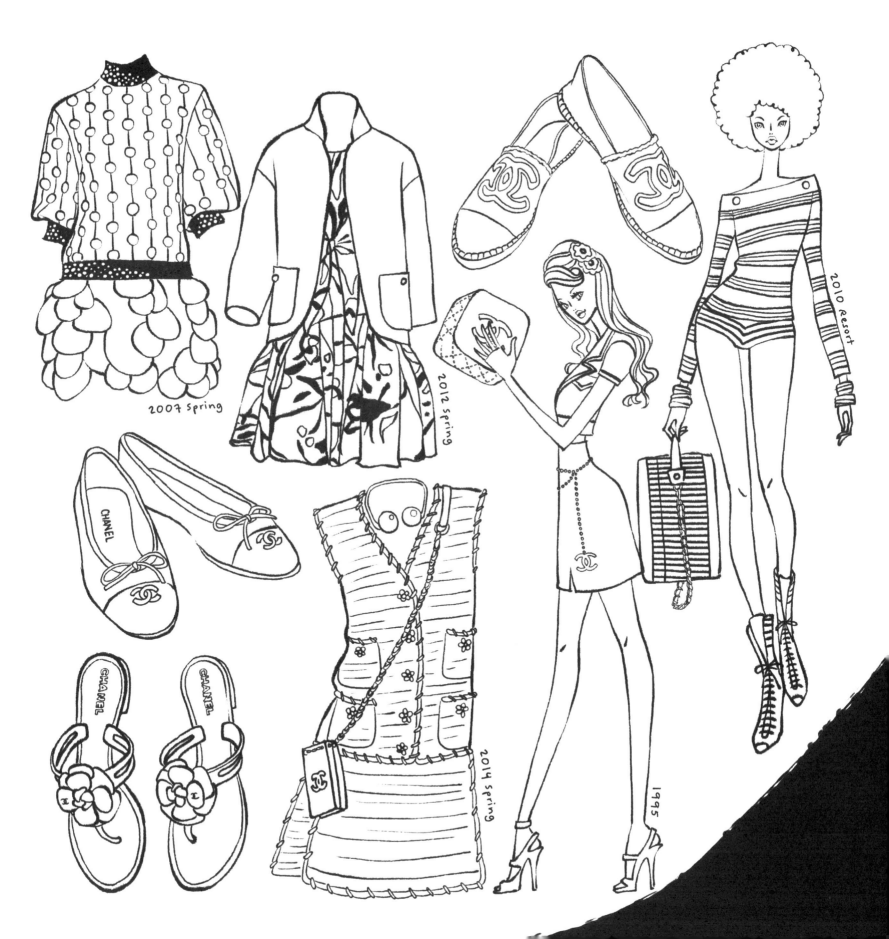

2007 spring

2012 spring

2010 Resort

CHANEL

CHANEL CHANEL

2014 spring

1995

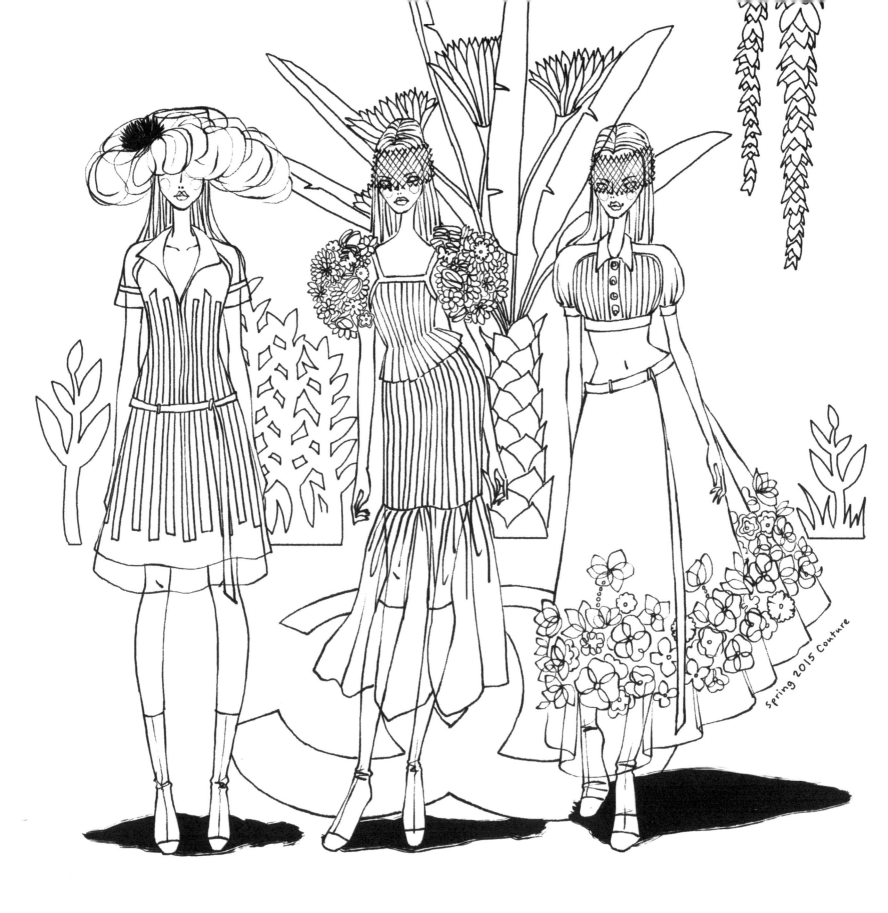

Spring 2015 Couture

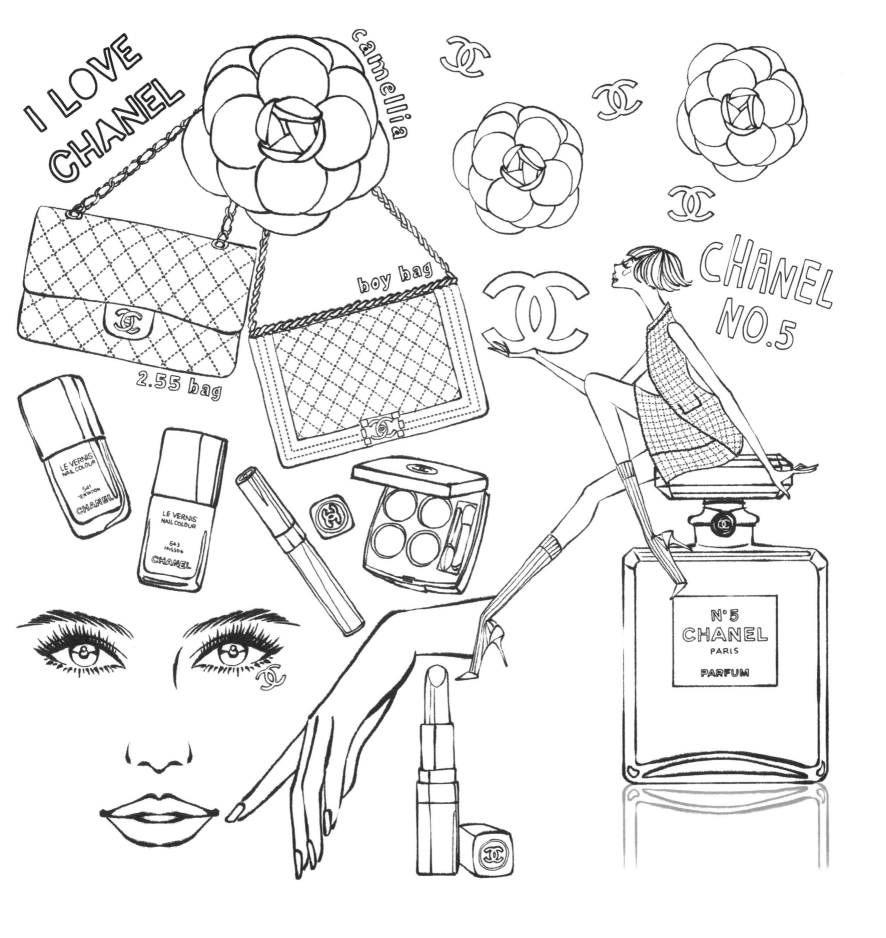

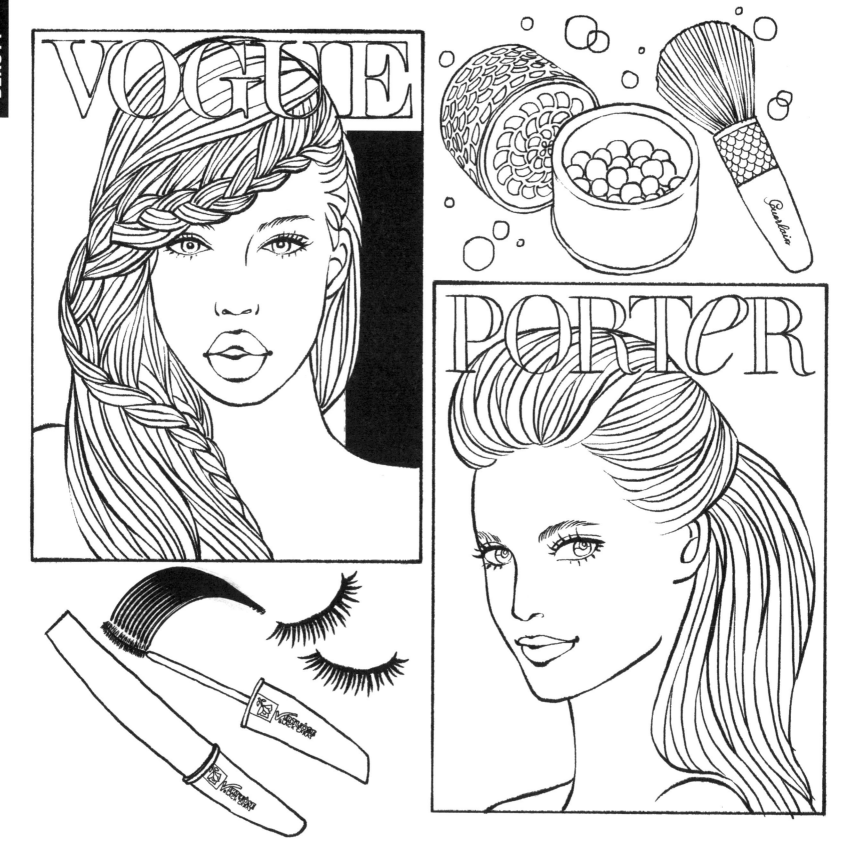

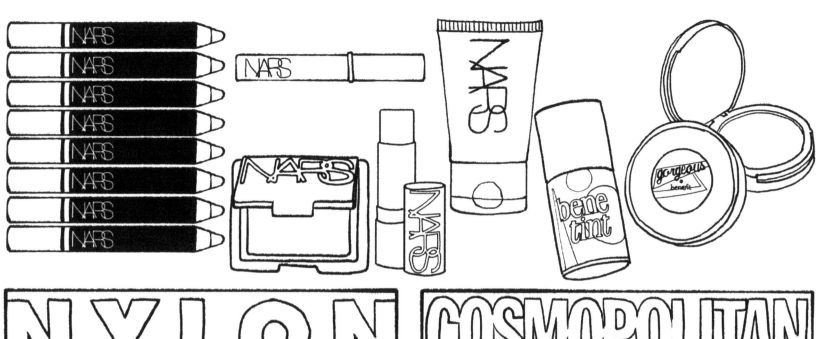

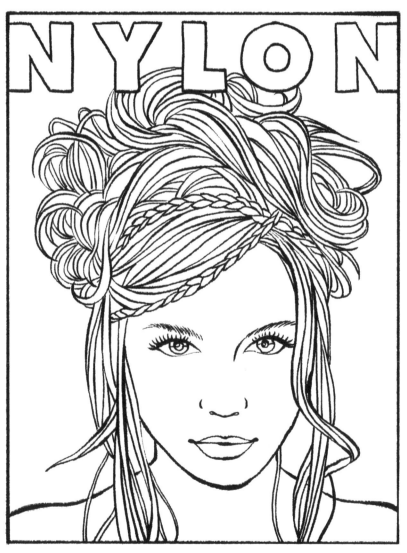

NYLON

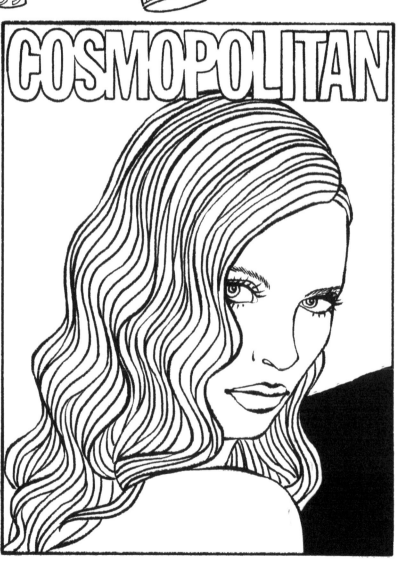

COSMOPOLITAN

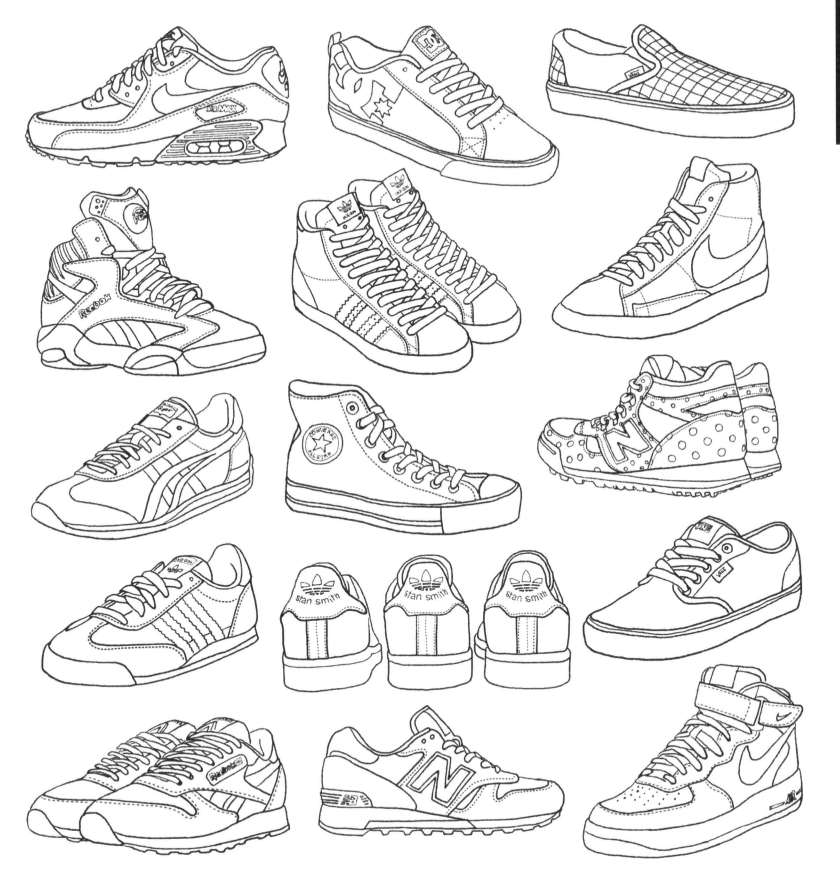

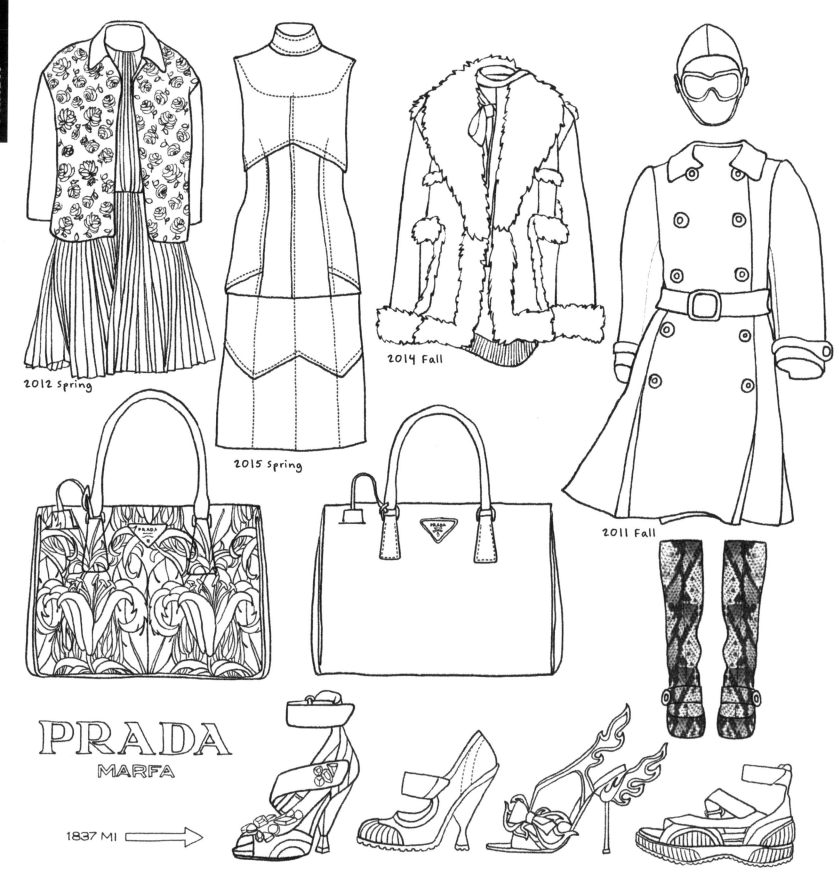

PRADA

2012 Spring

2015 Spring

2014 Fall

2011 Fall

PRADA
MARFA

1837 MI →

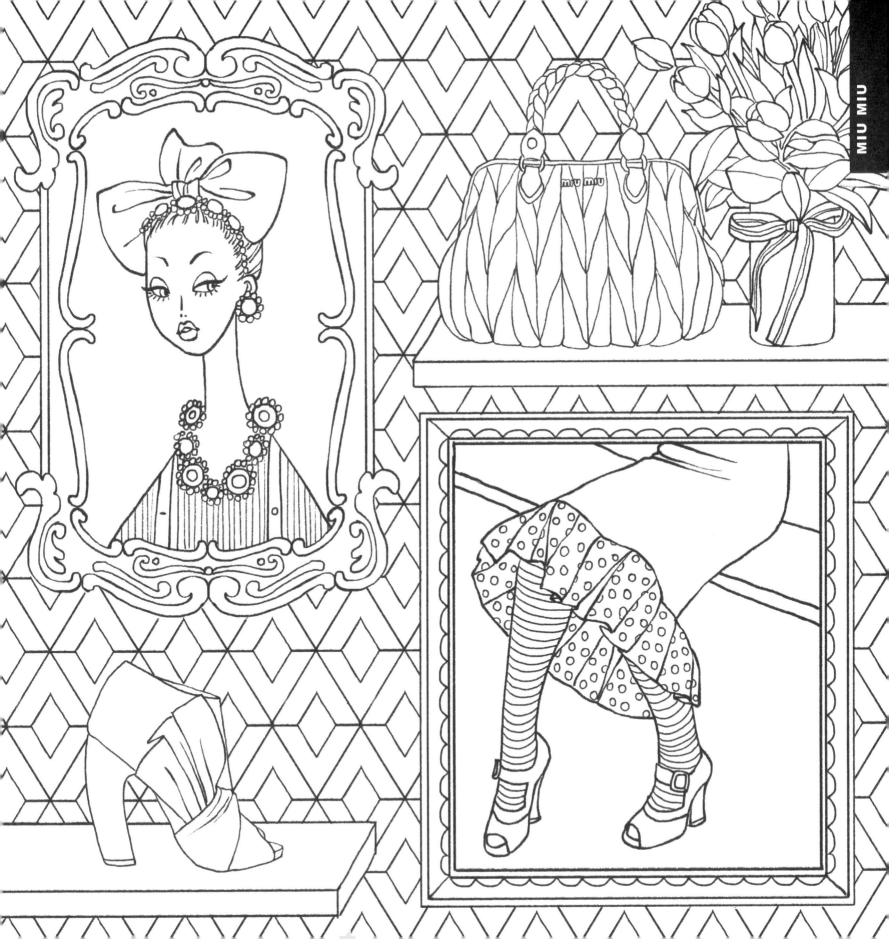

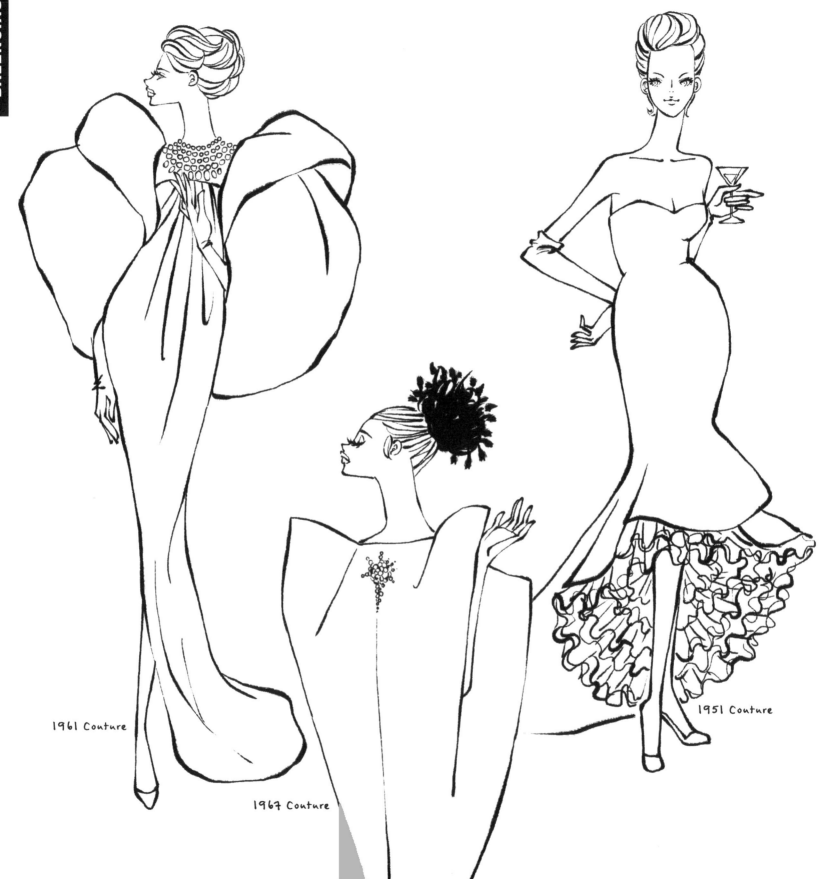

1961 Couture

1967 Couture

1951 Couture

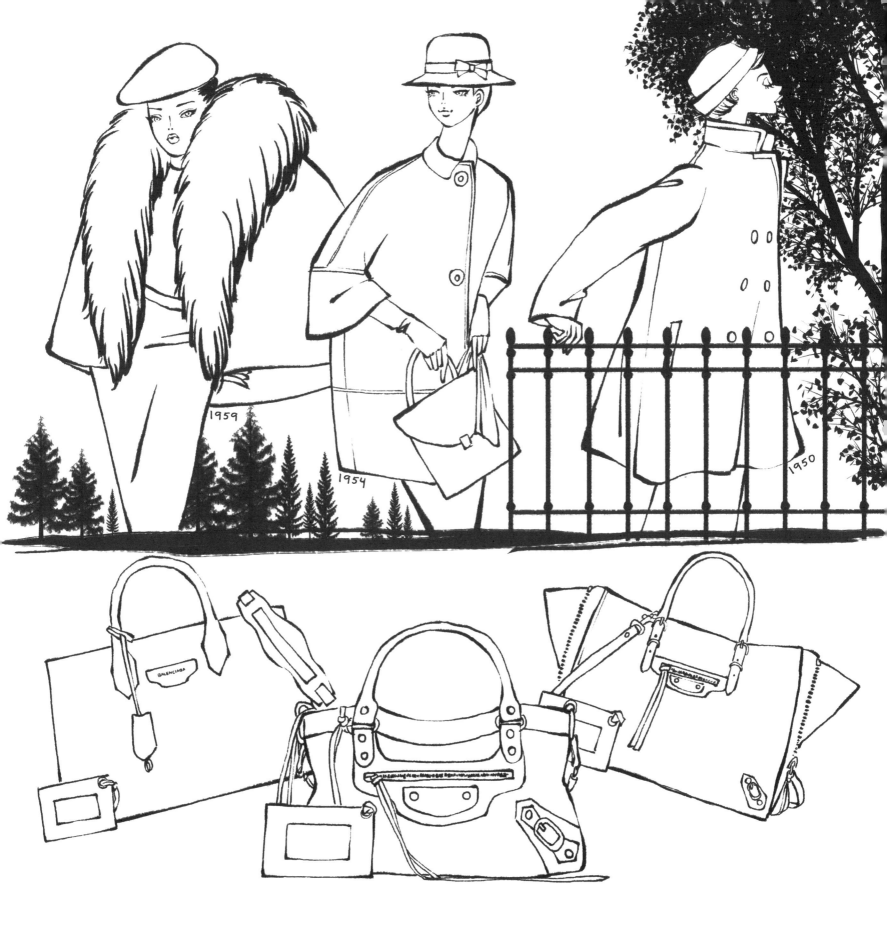

1959

1954

1950

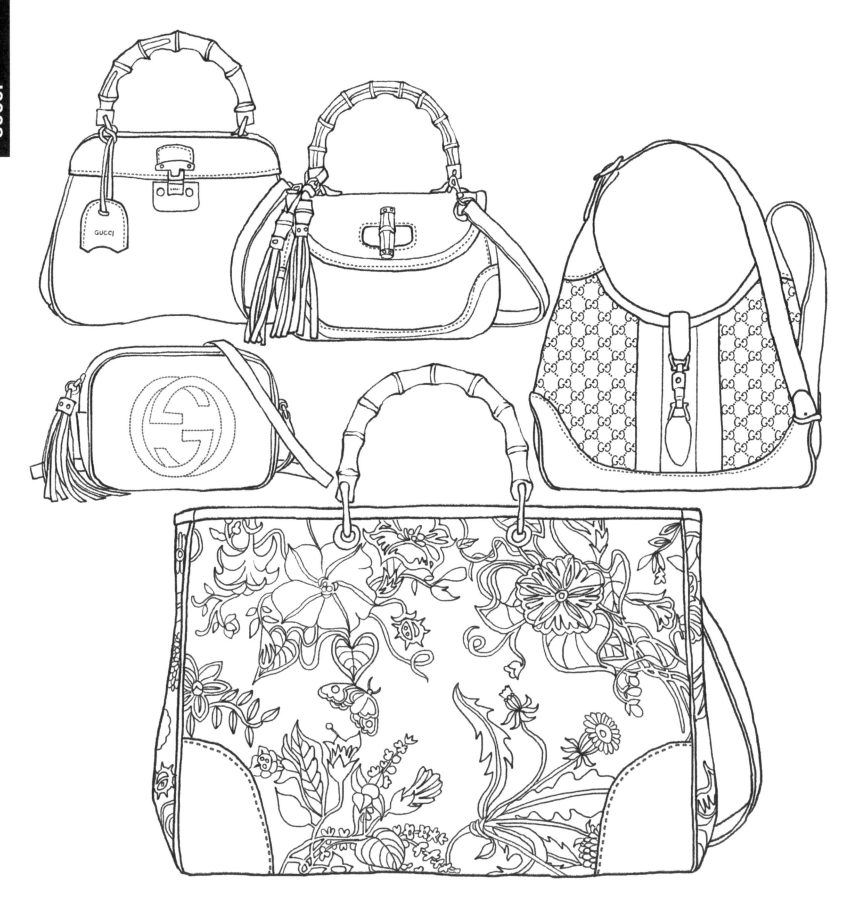

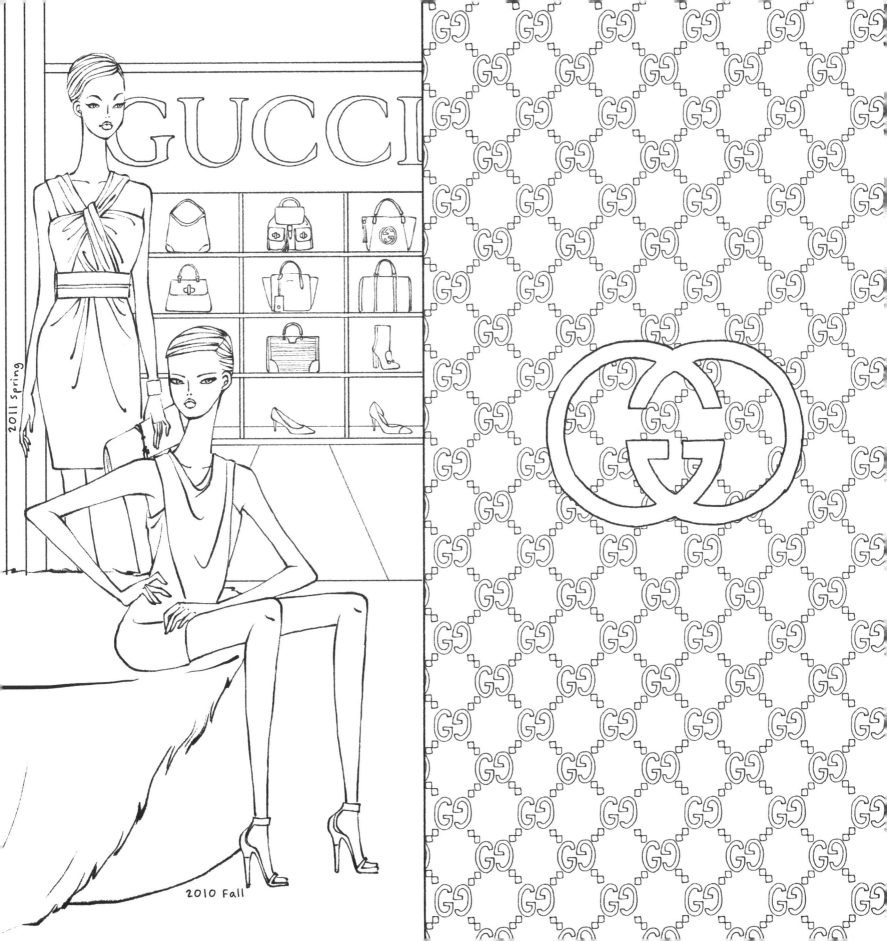

GUCCI

2011 spring

2010 Fall

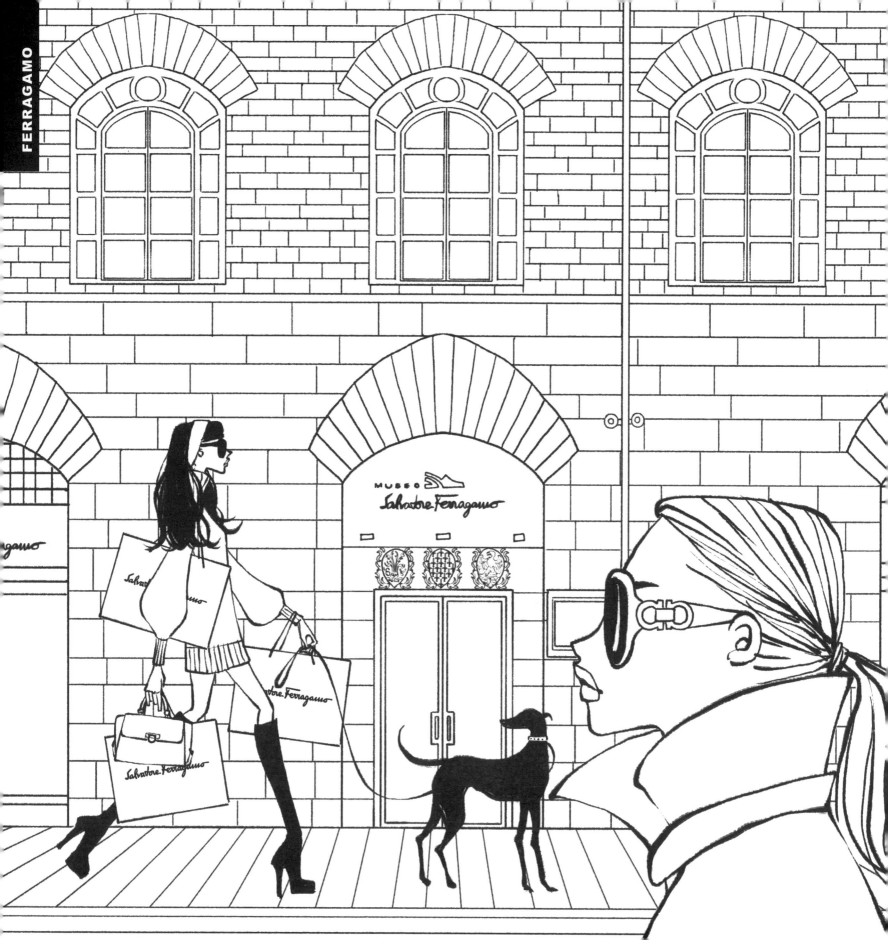

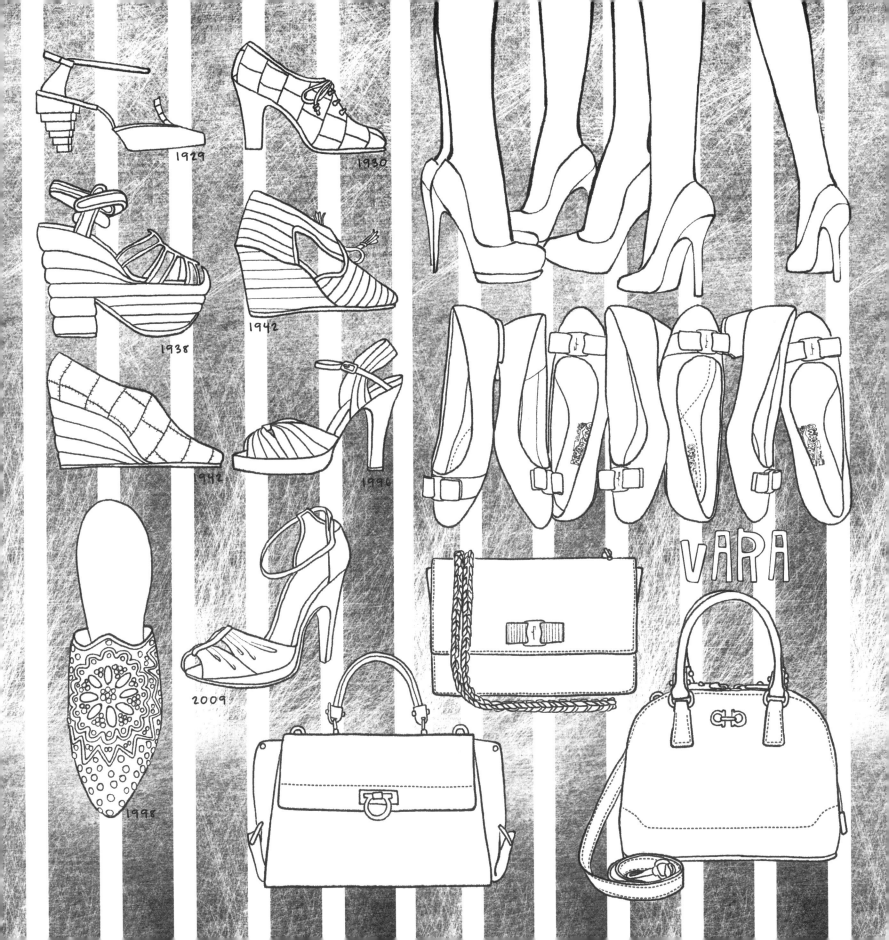

1929

1930

1938

1942

1942

1996

2009

1998

VARA

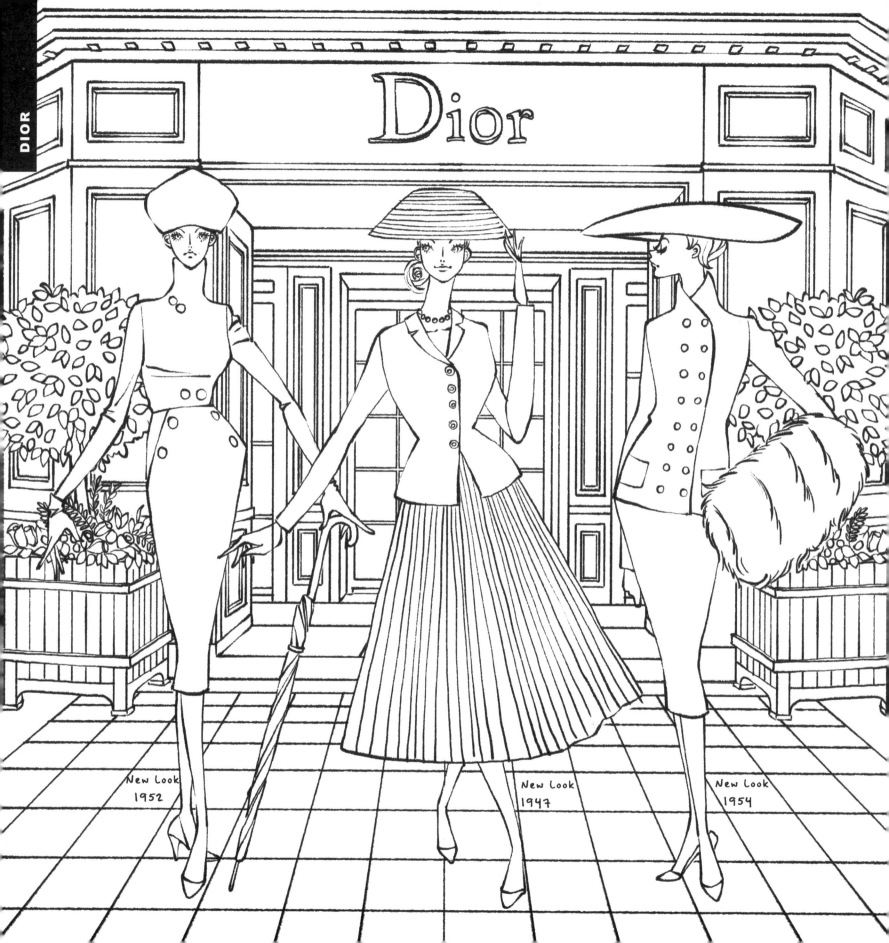

New Look
1952

New Look
1947

New Look
1954

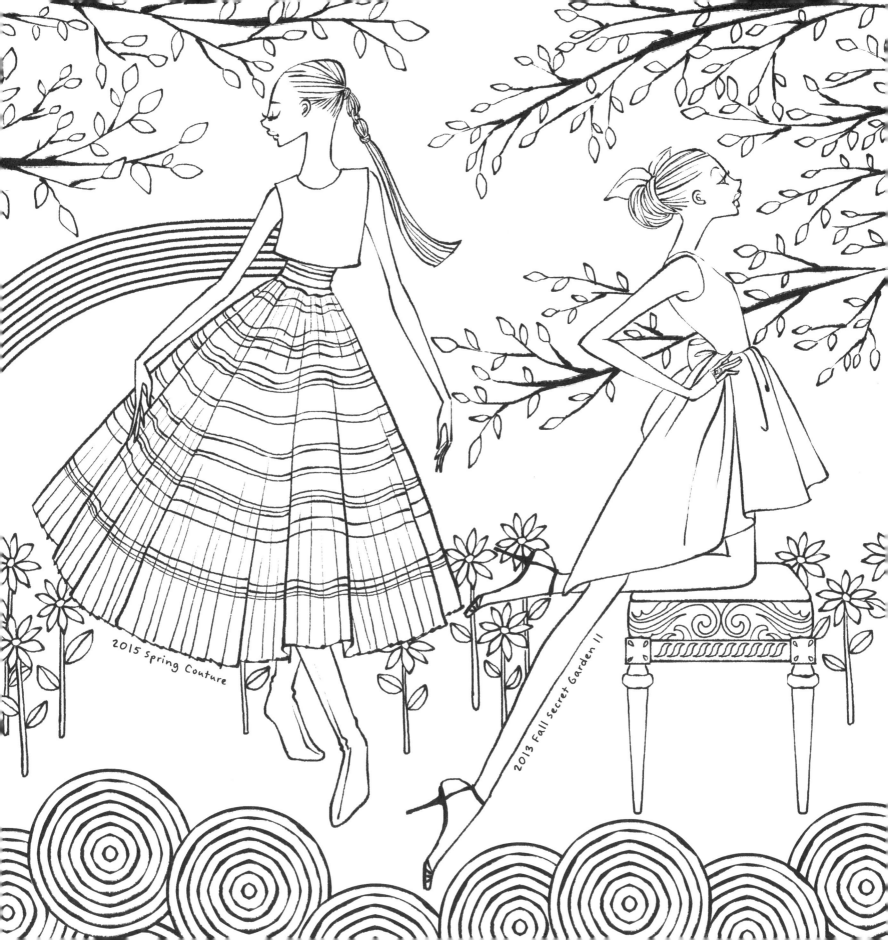

2015 Spring Couture

2013 Fall Secret Garden II

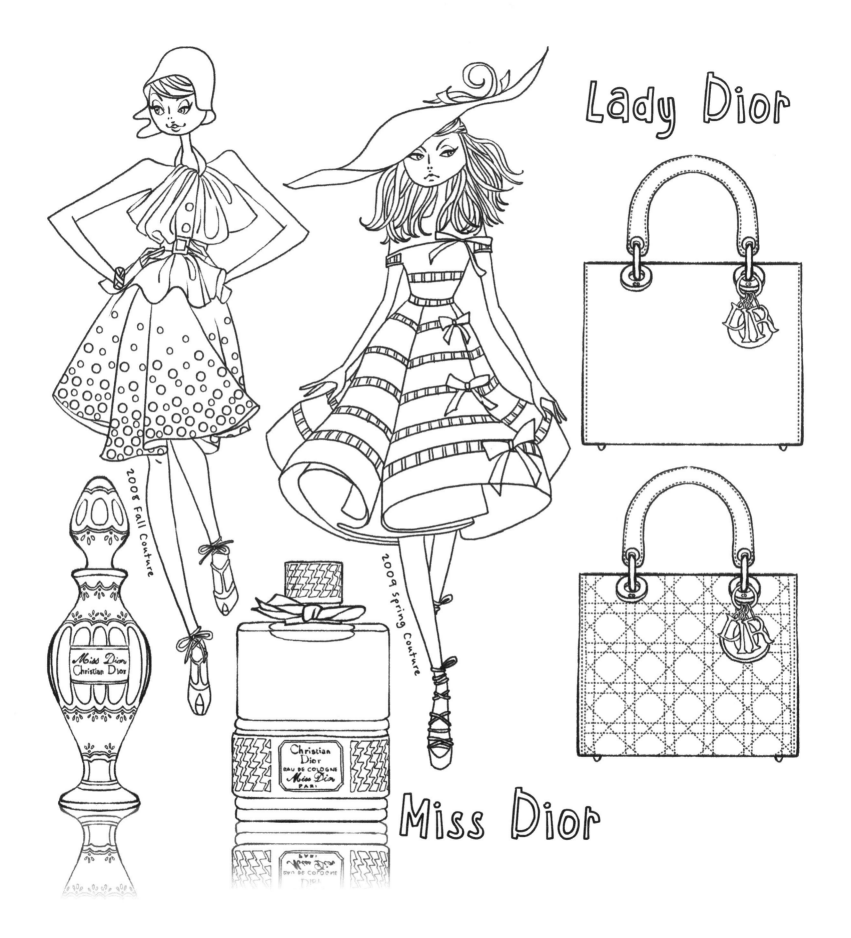

Lady Dior

Miss Dior

2008 Fall Couture

2009 Spring Couture

Miss Dior
Christian Dior

Christian
Dior
EAU DE COLOGNE
Miss Dior
PARIS

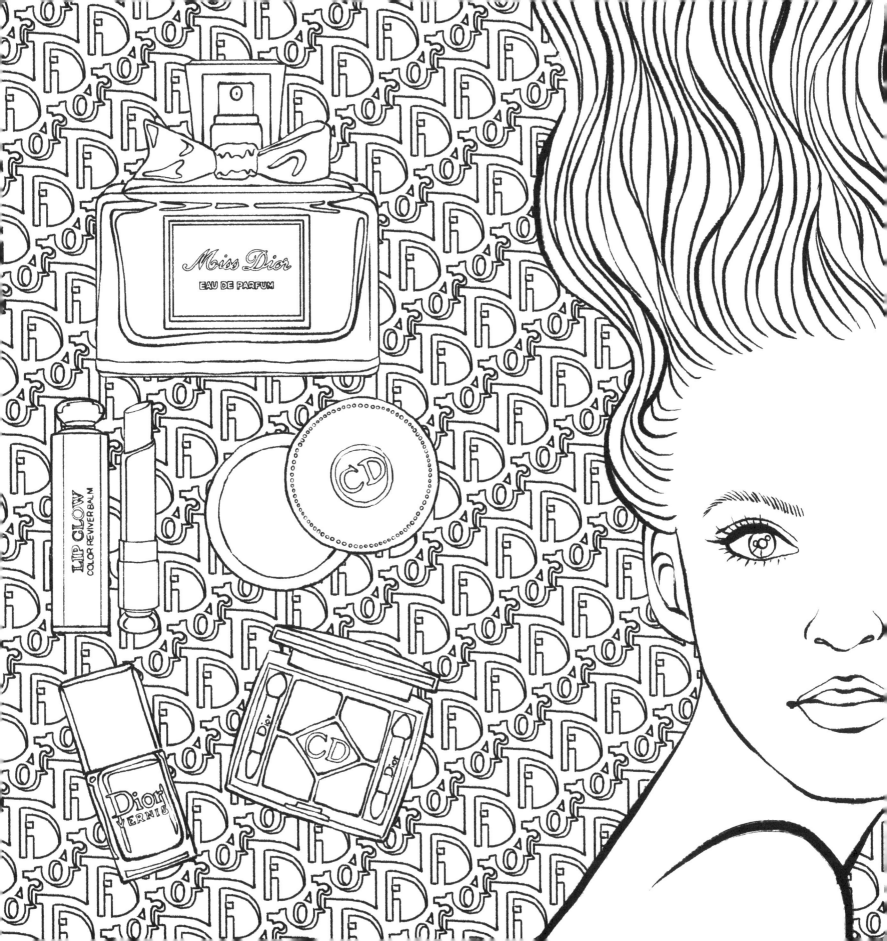

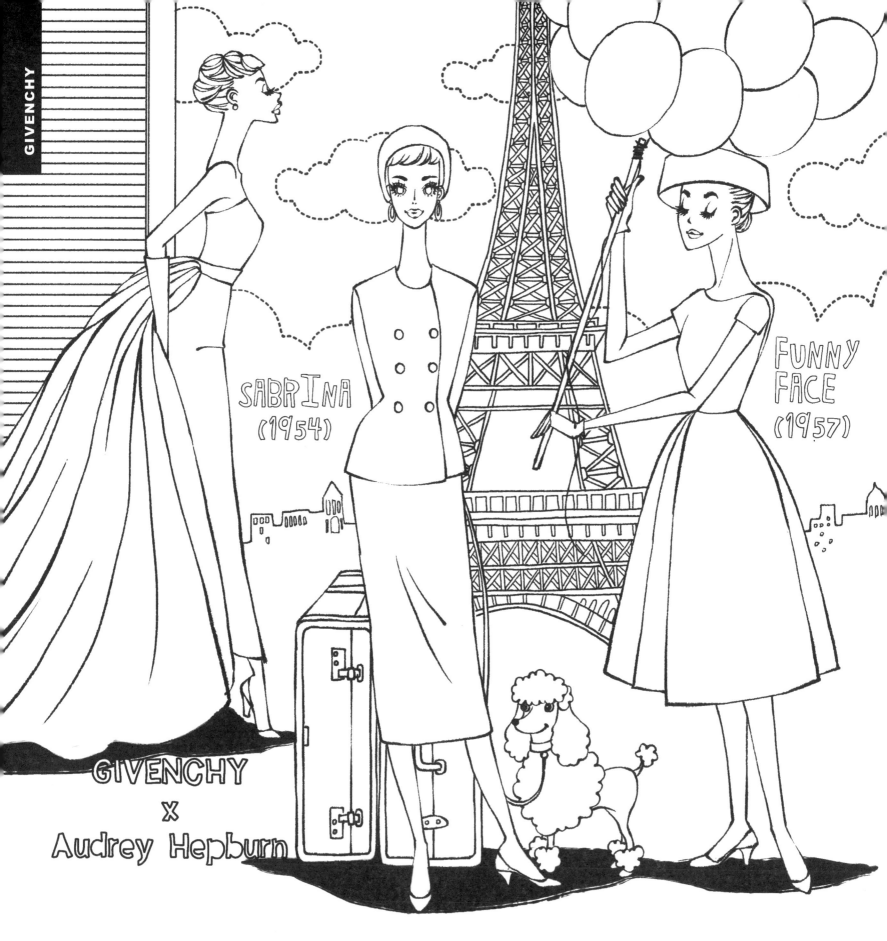

SABRINA
(1954)

FUNNY
FACE
(1957)

GIVENCHY
x
Audrey Hepburn

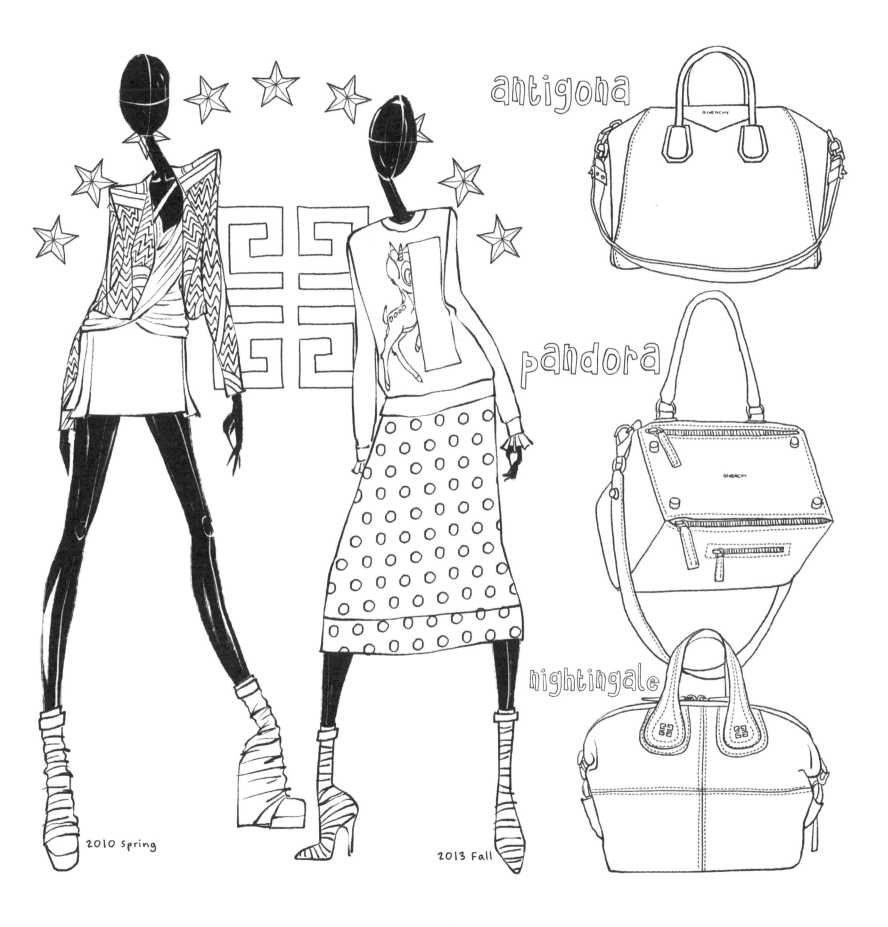

antigona

pandora

nightingale

2010 spring

2013 Fall

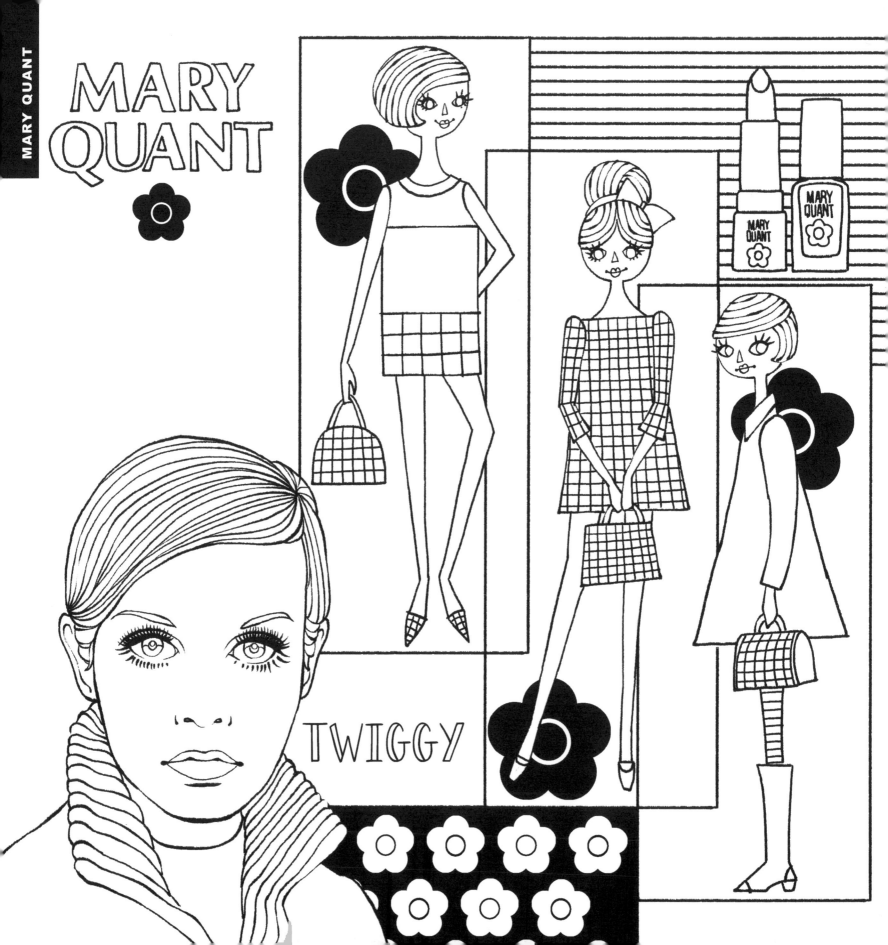

MARY
QUANT

TWIGGY

MARY QUANT

MARY QUANT

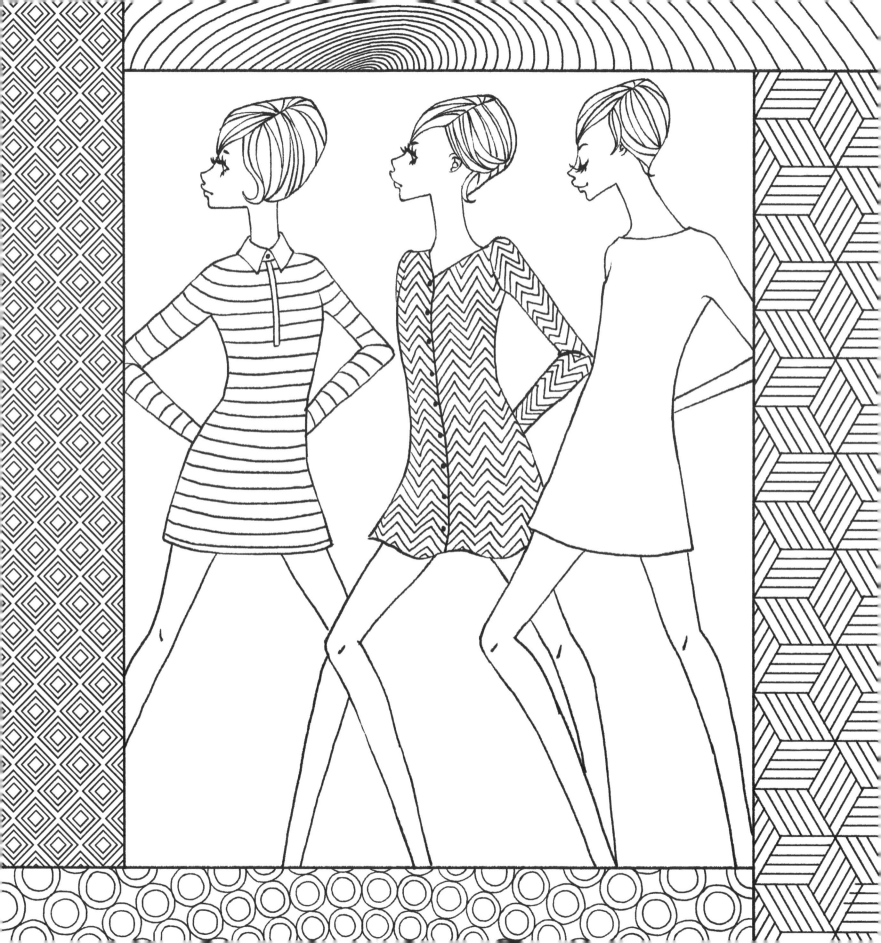

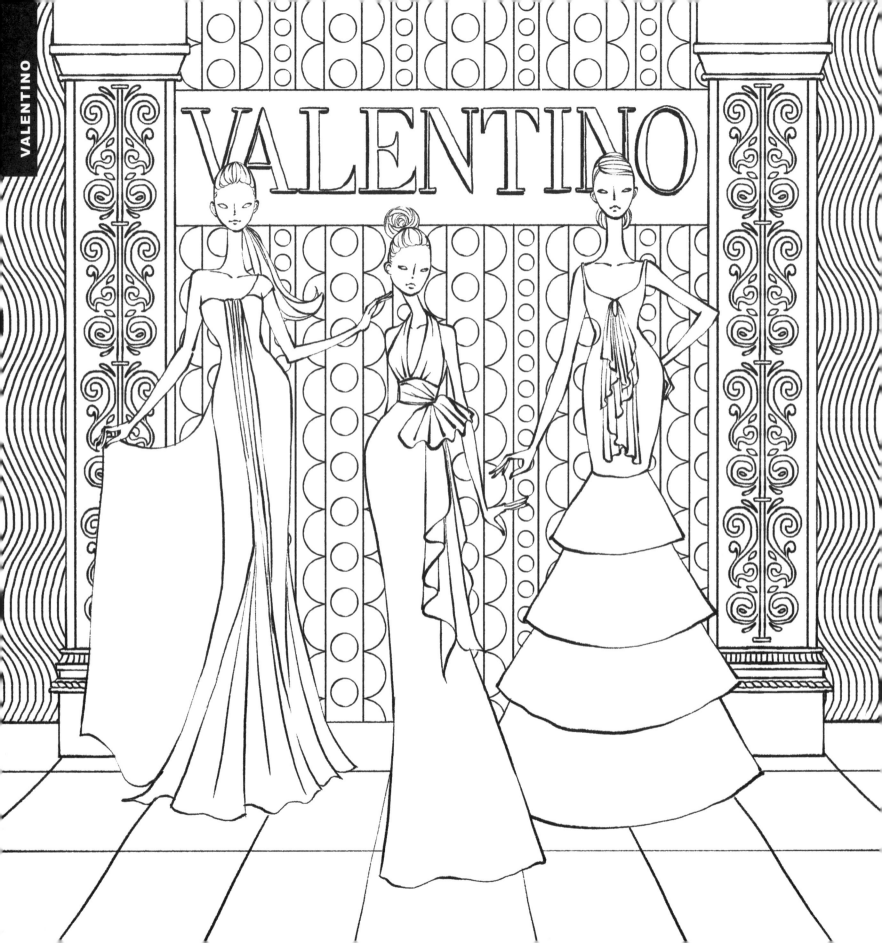

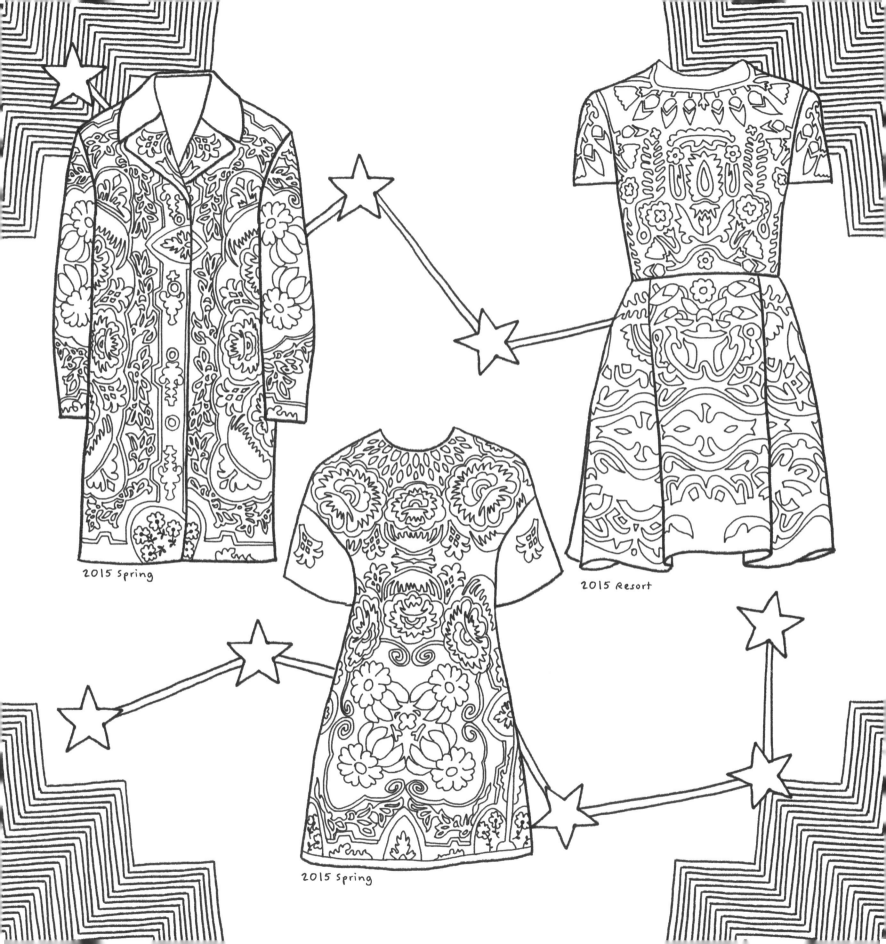

2015 Spring

2015 Resort

2015 Spring

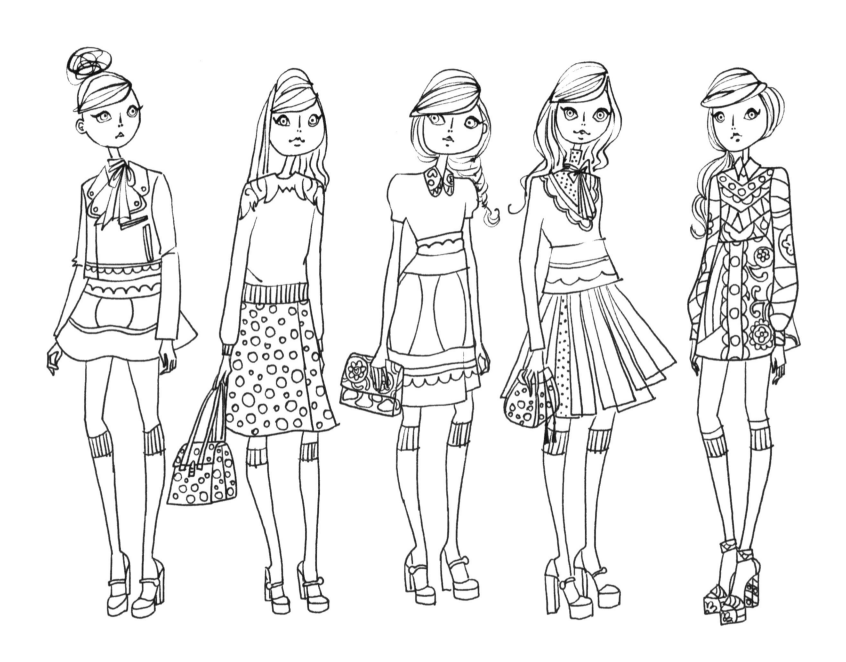

Red Valentino 2015 Pre Fall

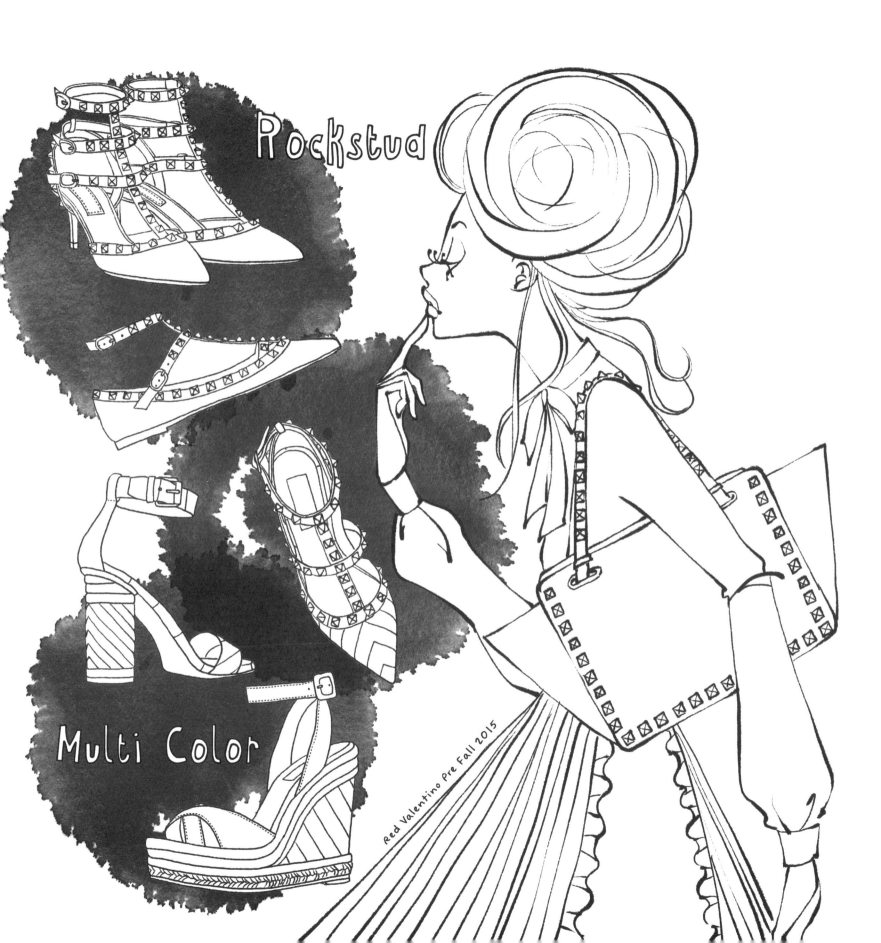

Rockstud

Multi Color

Red Valentino Pre Fall 2015

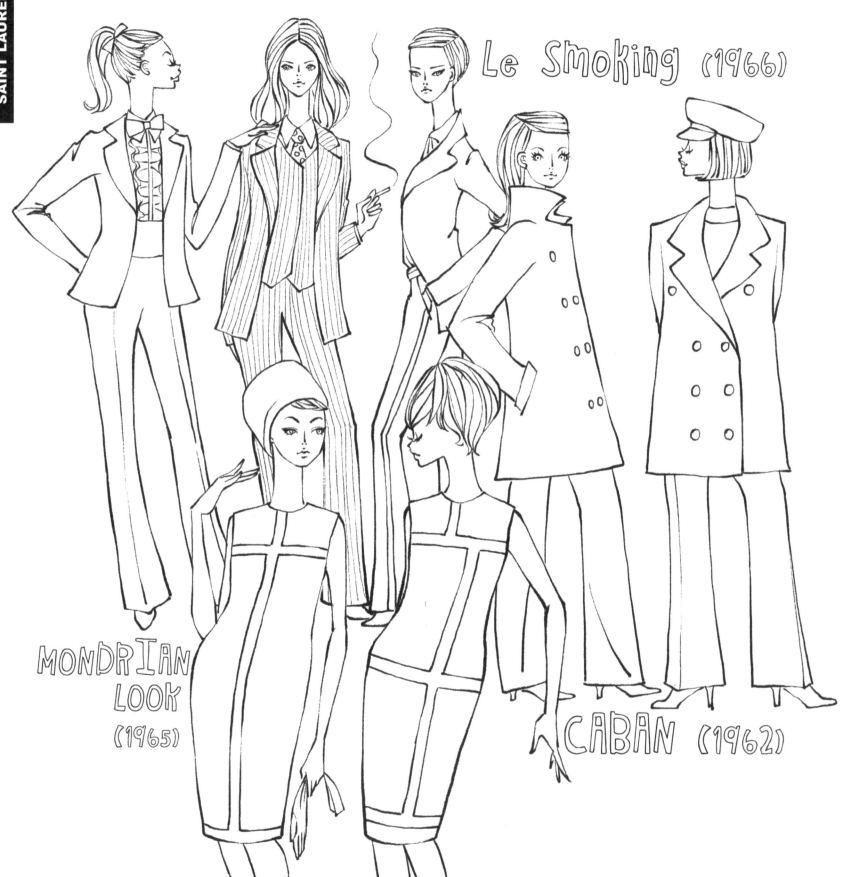

SAINT LAURENT

Le Smoking (1966)

MONDRIAN LOOK (1965)

CABAN (1962)

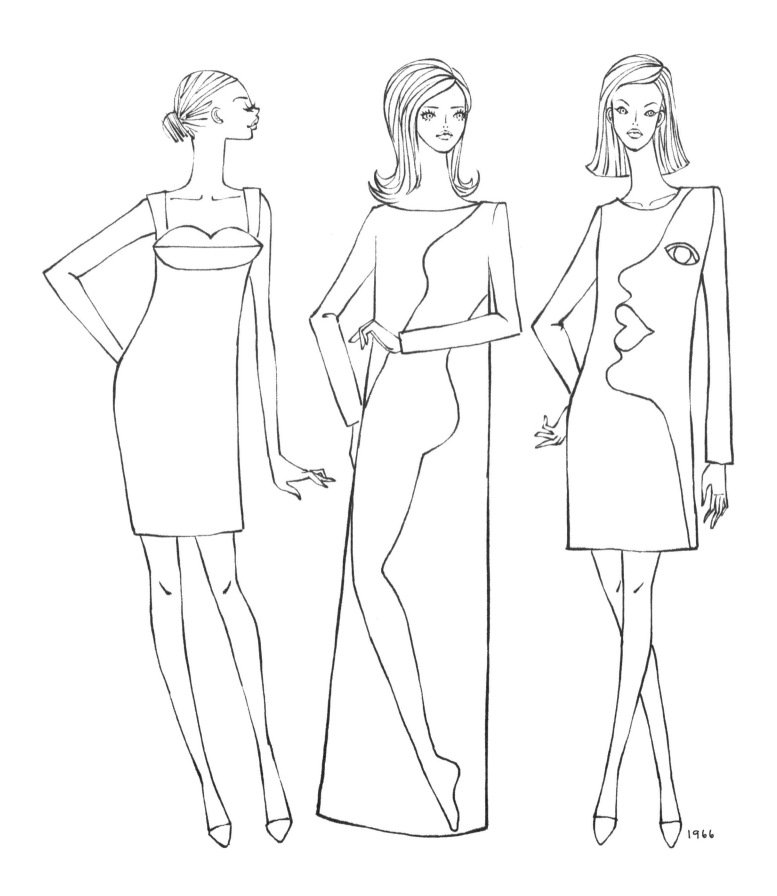

1966

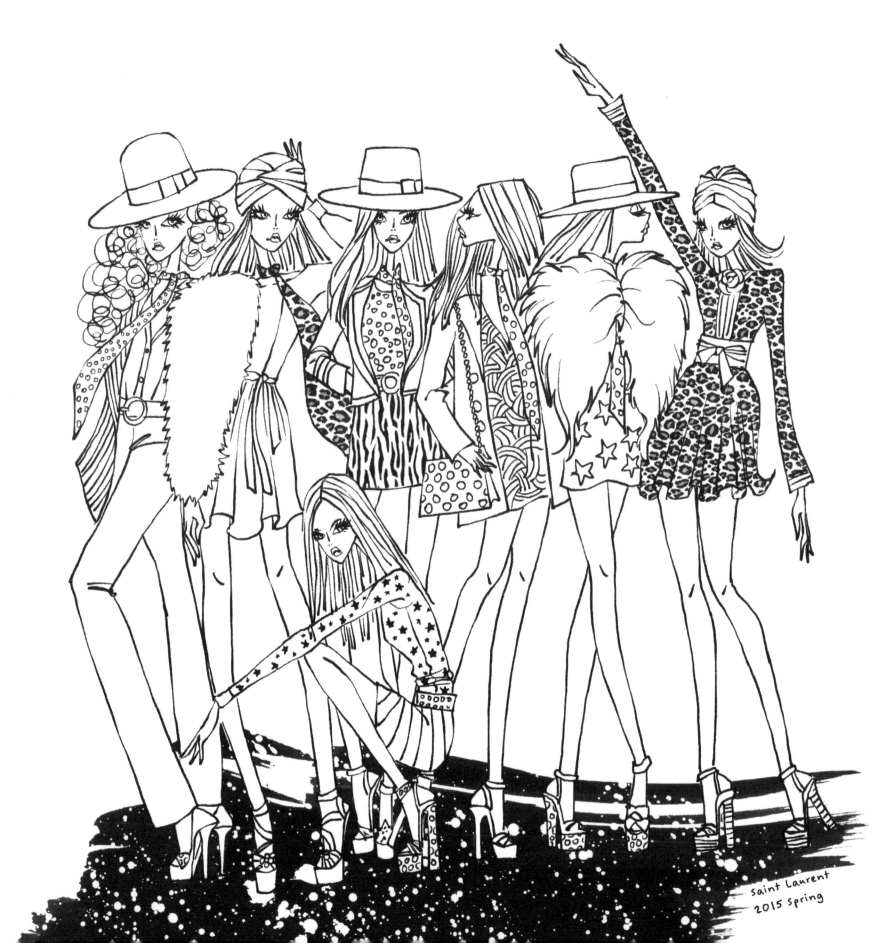

saint Laurent
2015 spring

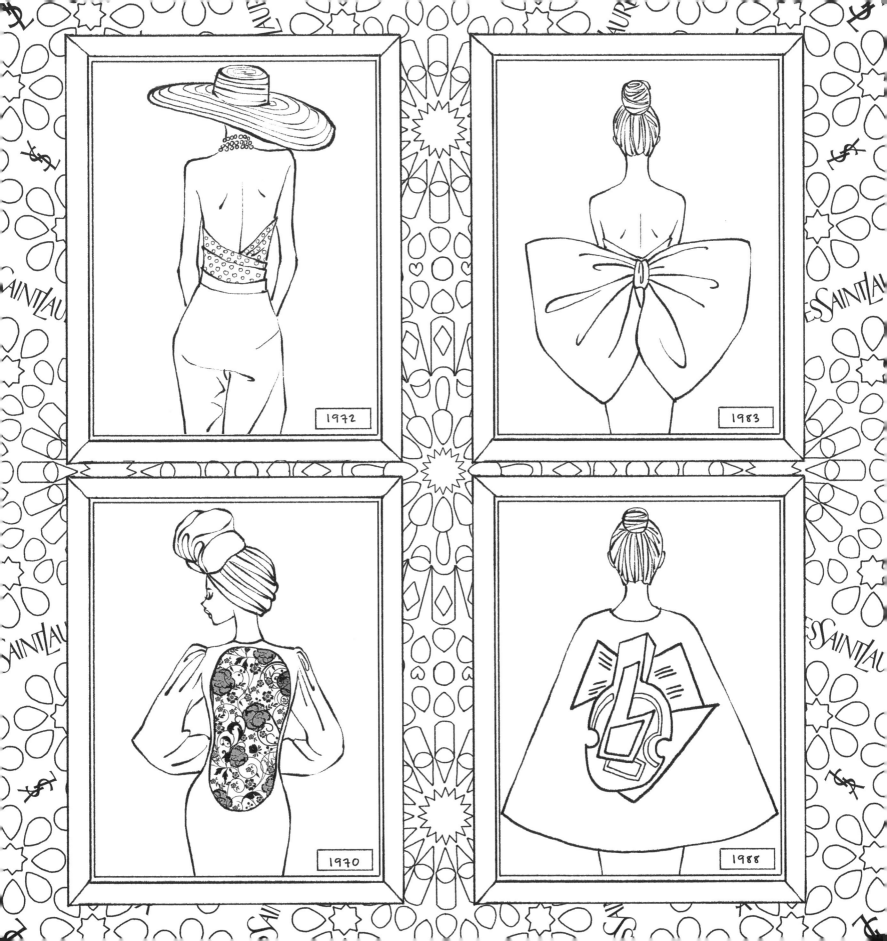

2015 spring

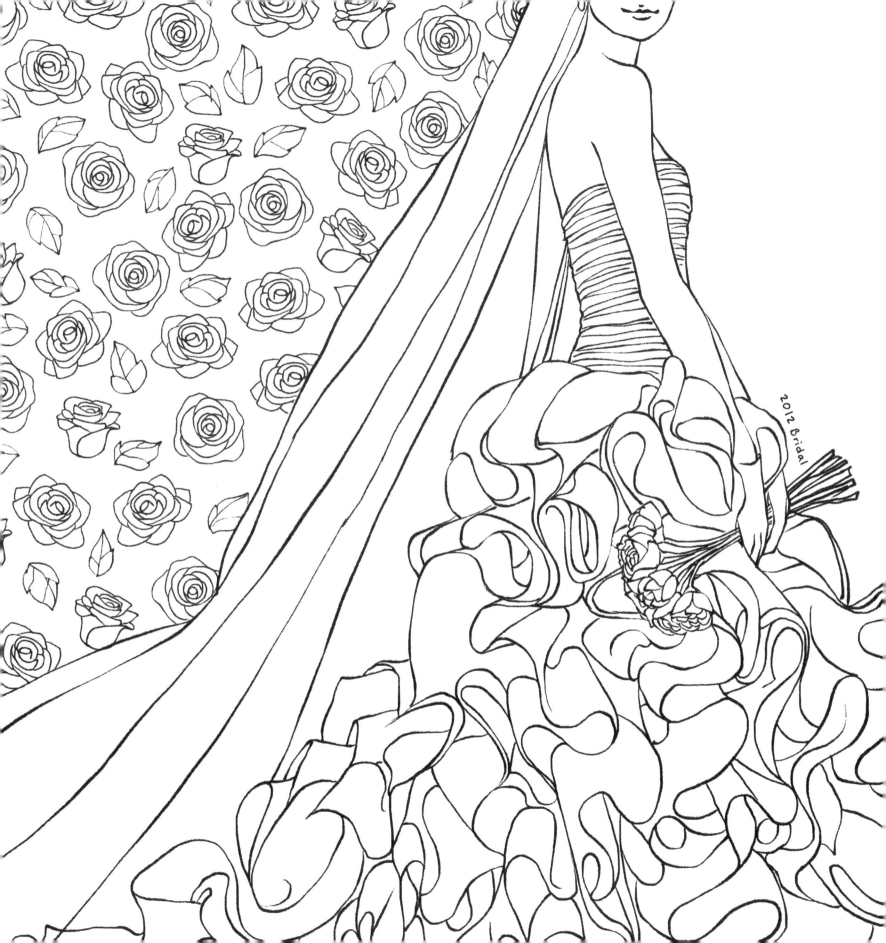

WOMEN

MEN

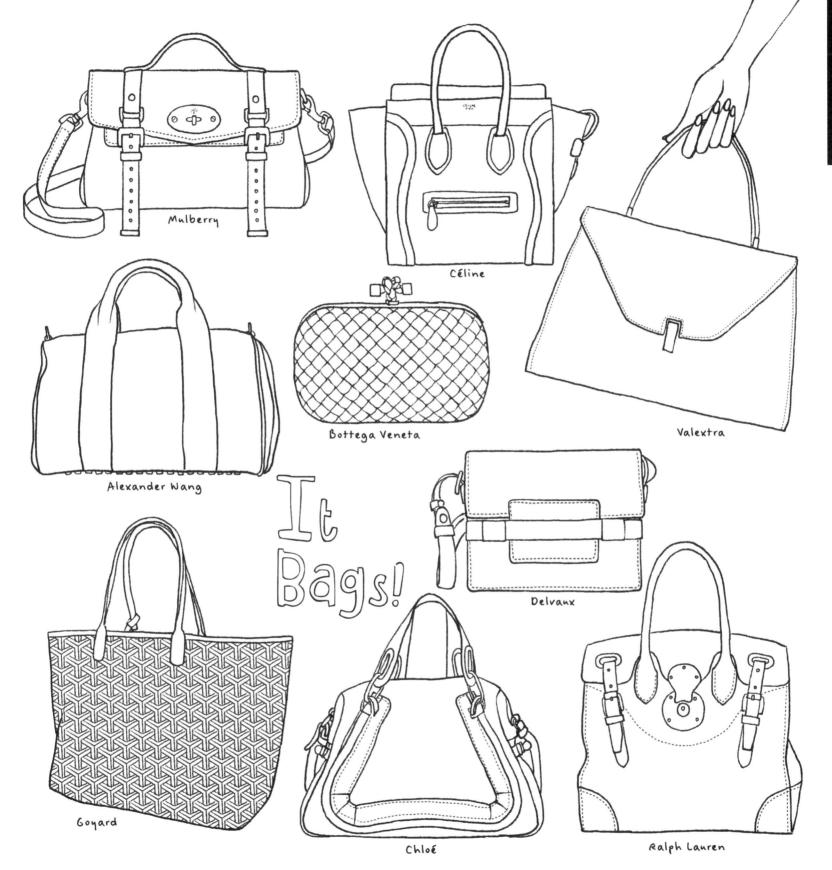

Mulberry

Céline

Valextra

Bottega Veneta

Alexander Wang

It Bags!

Delvaux

Goyard

Chloé

Ralph Lauren

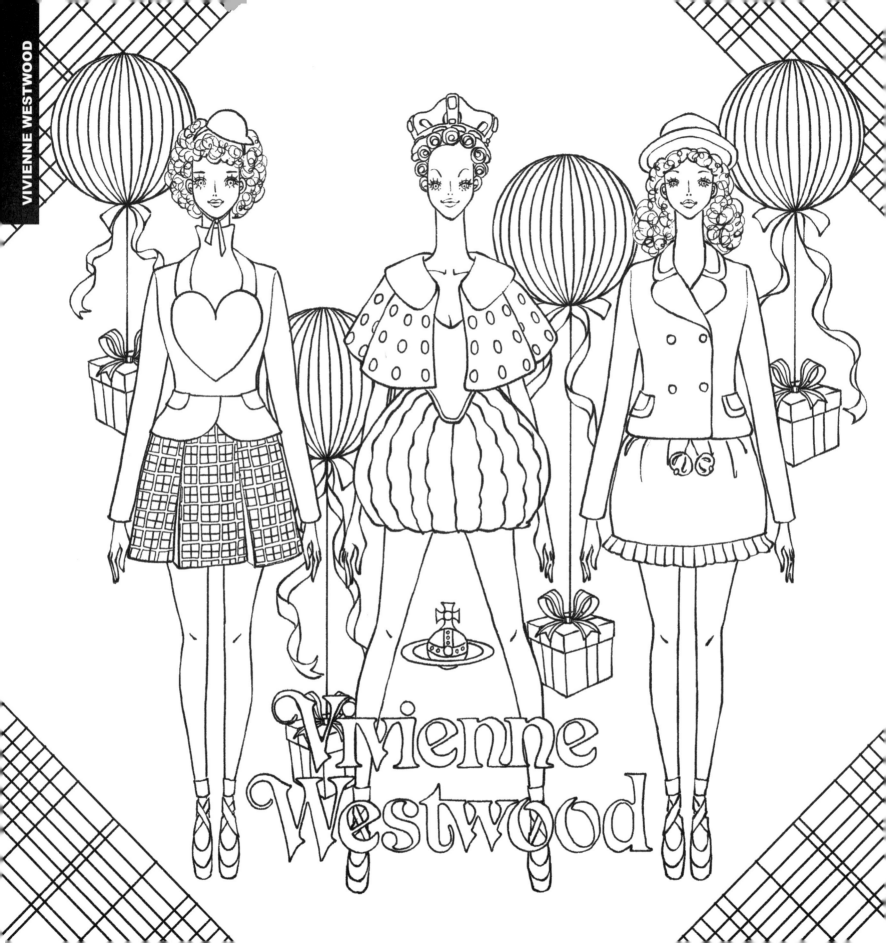

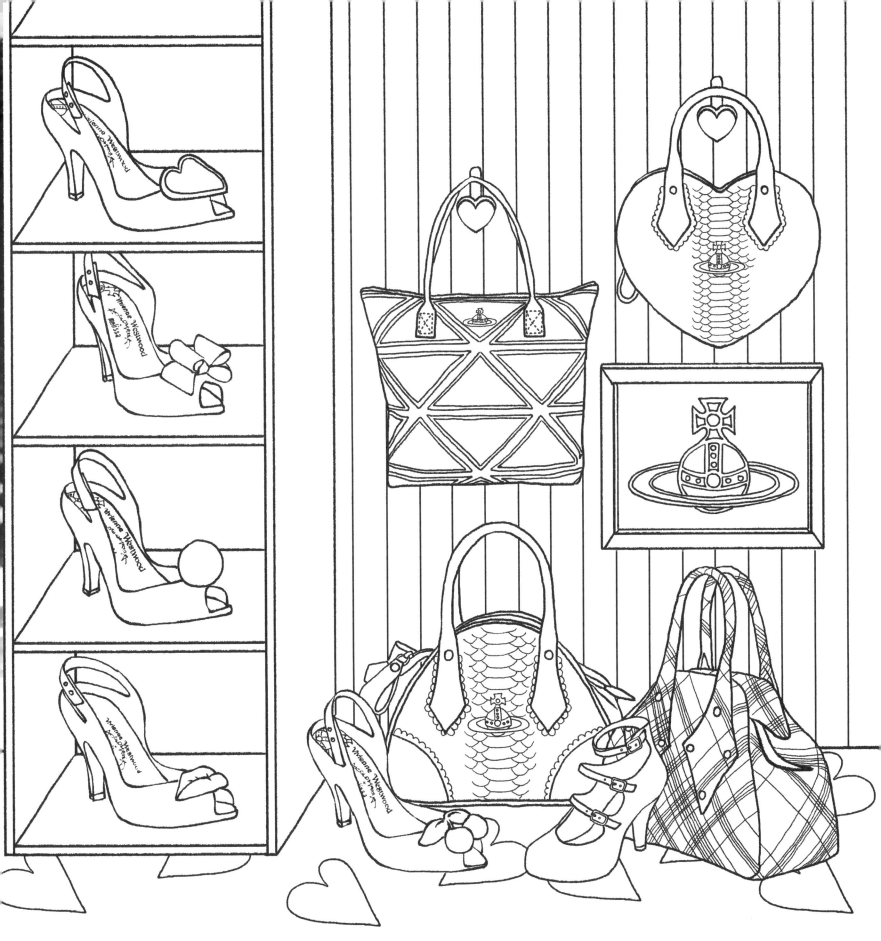

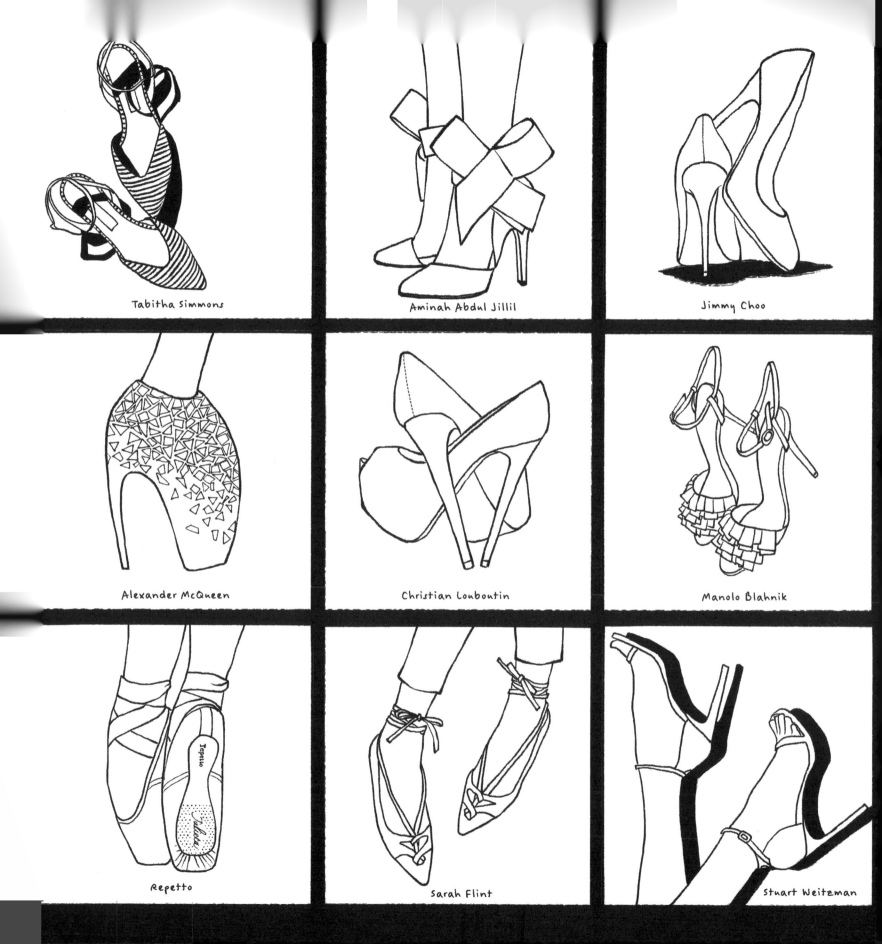

Tabitha Simmons

Aminah Abdul Jillil

Jimmy Choo

Alexander McQueen

Christian Louboutin

Manolo Blahnik

Repetto

Sarah Flint

Stuart Weitzman

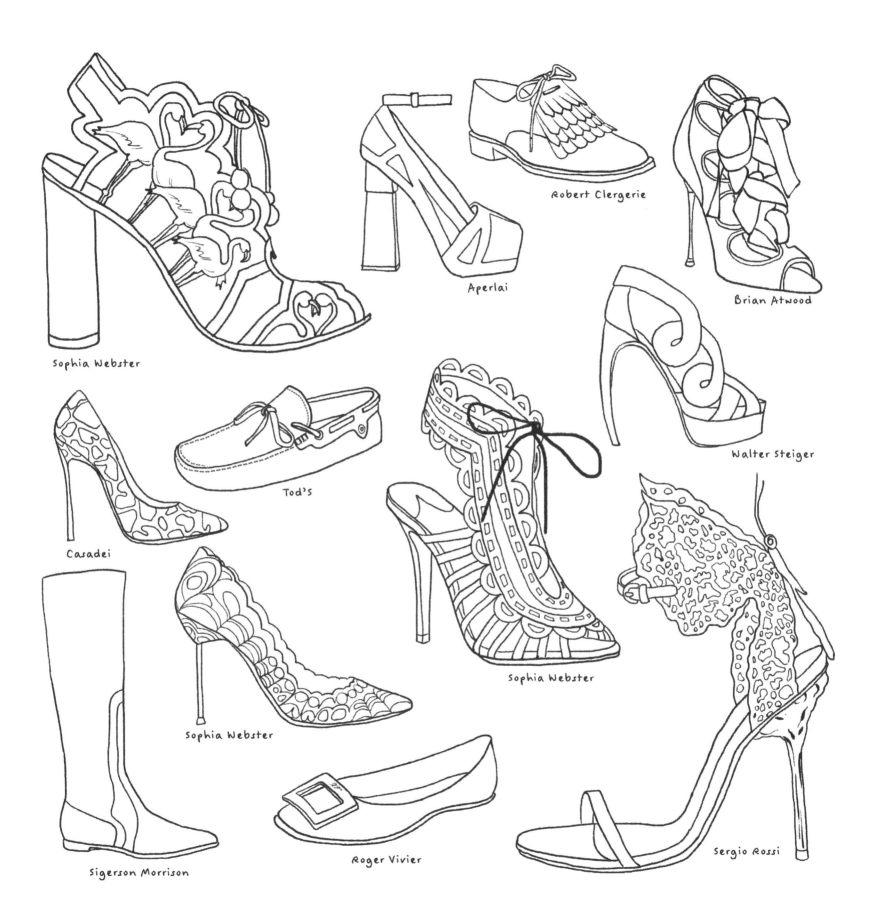

Sophia Webster

Aperlai

Robert Clergerie

Brian Atwood

Casadei

Tod's

Walter Steiger

Sophia Webster

Sophia Webster

Sigerson Morrison

Roger Vivier

Sergio Rossi

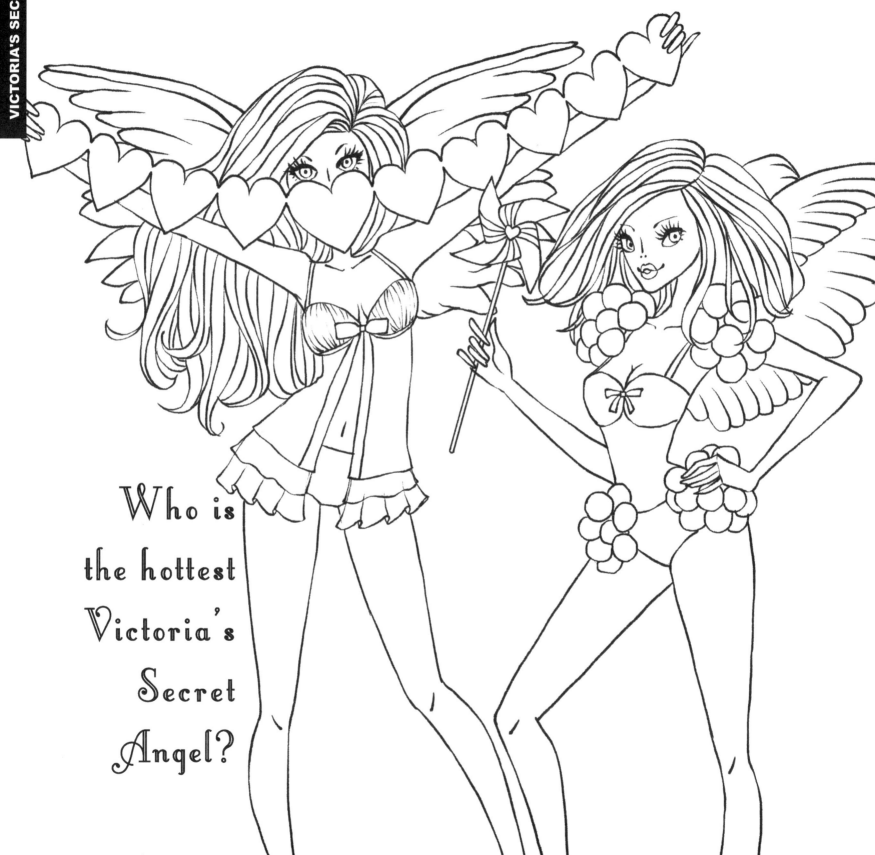

Who is
the hottest
Victoria's
Secret
Angel?

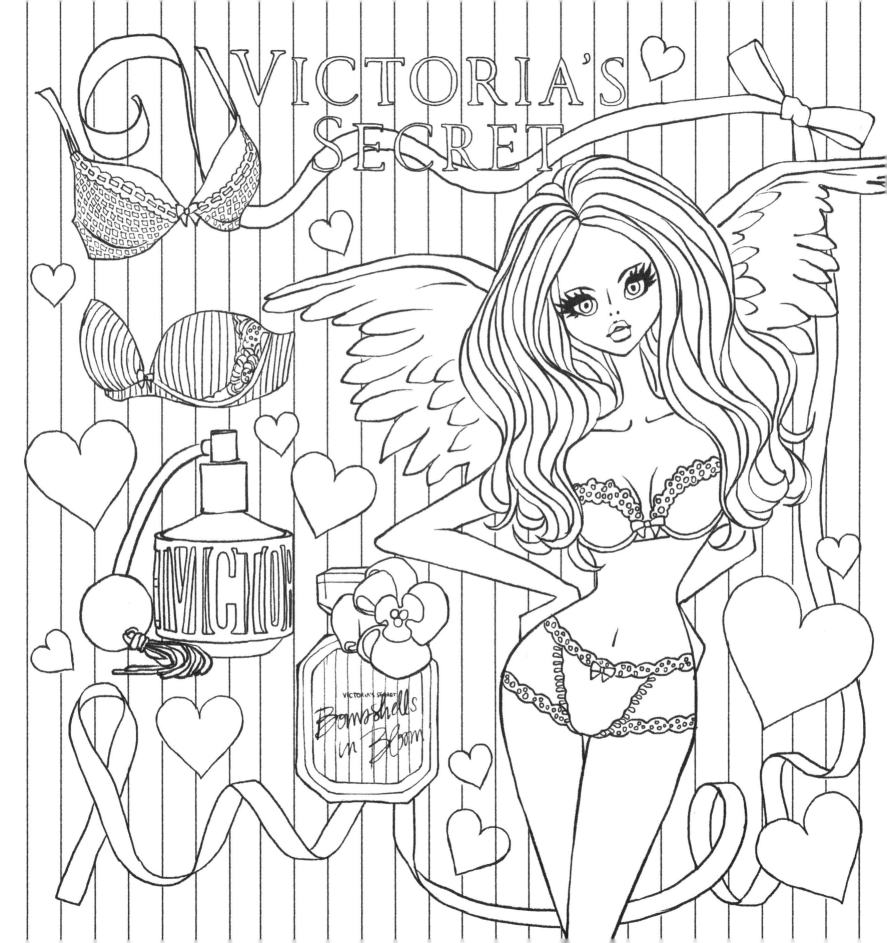

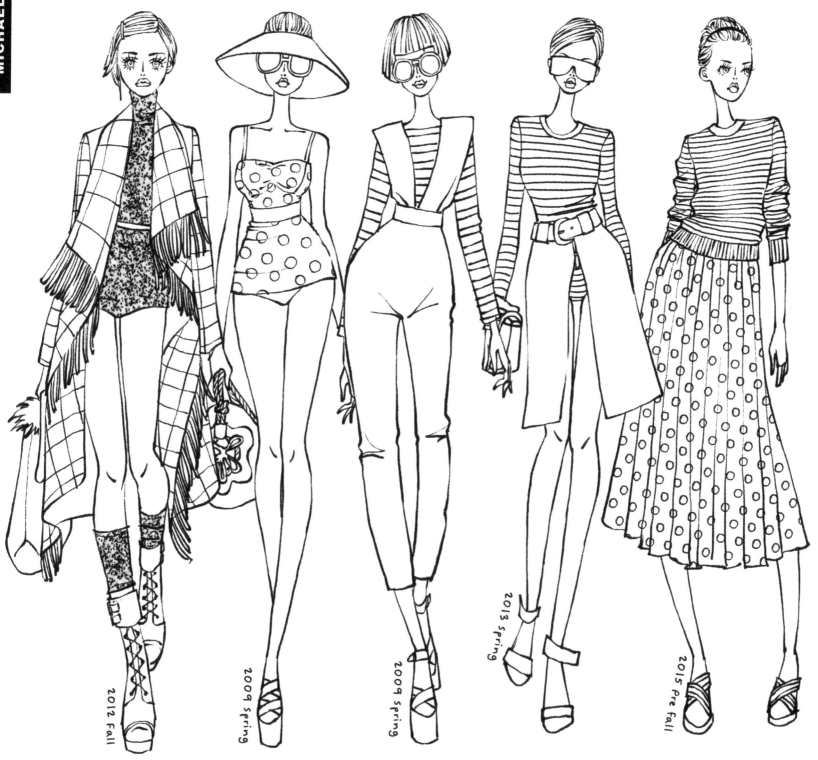

2012 Fall

2009 spring

2009 spring

2013 spring

2015 pre fall

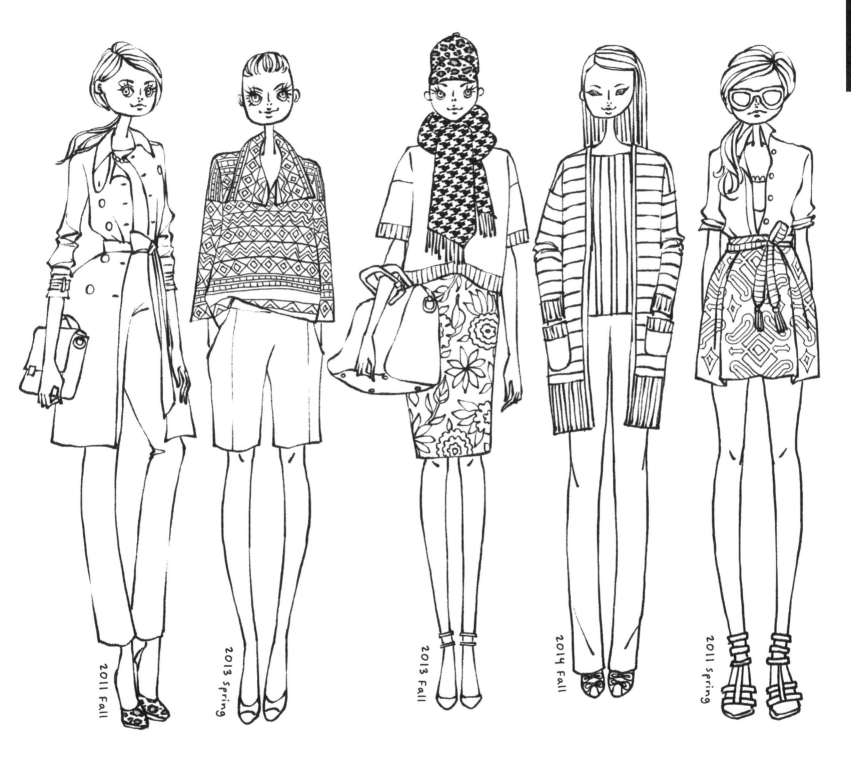

2011 Fall

2013 Spring

2013 Fall

2014 Fall

2011 Spring

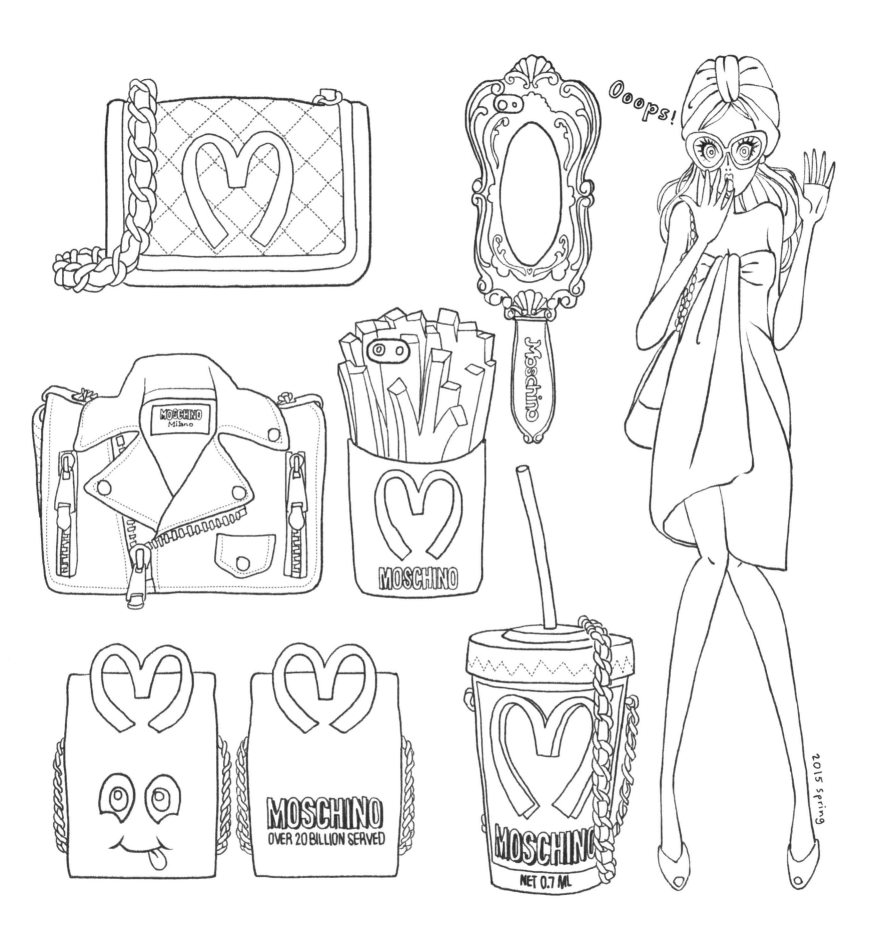

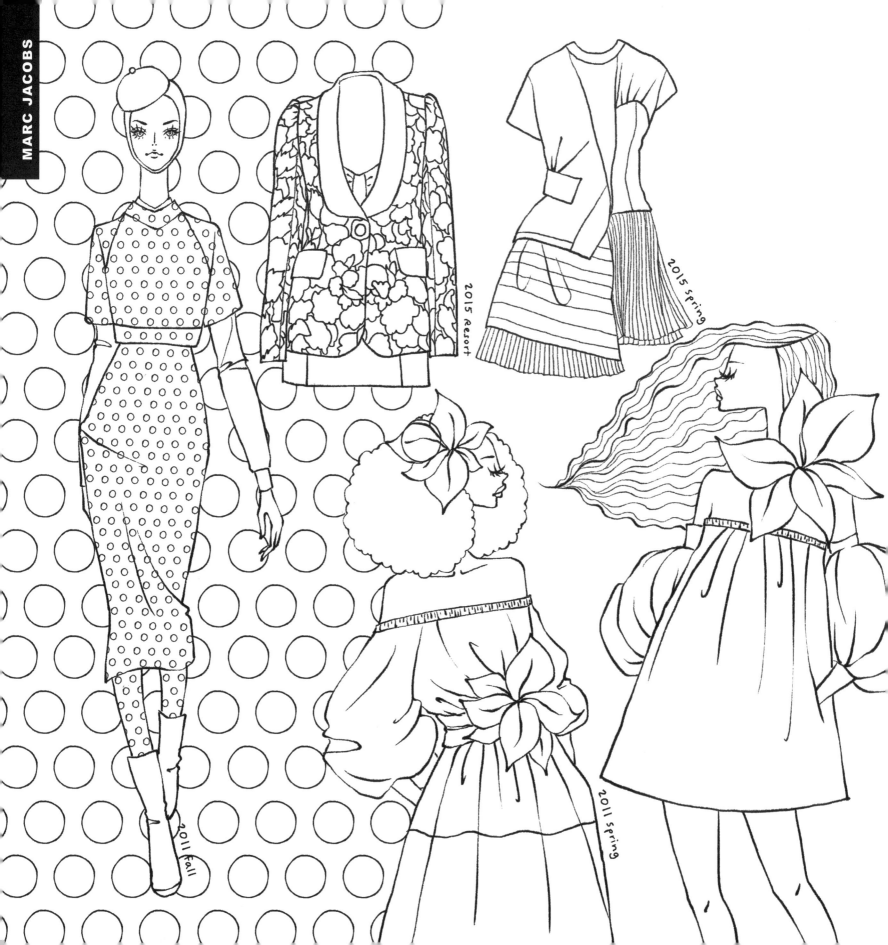

2015 resort

2015 spring

2011 Fall

2011 spring

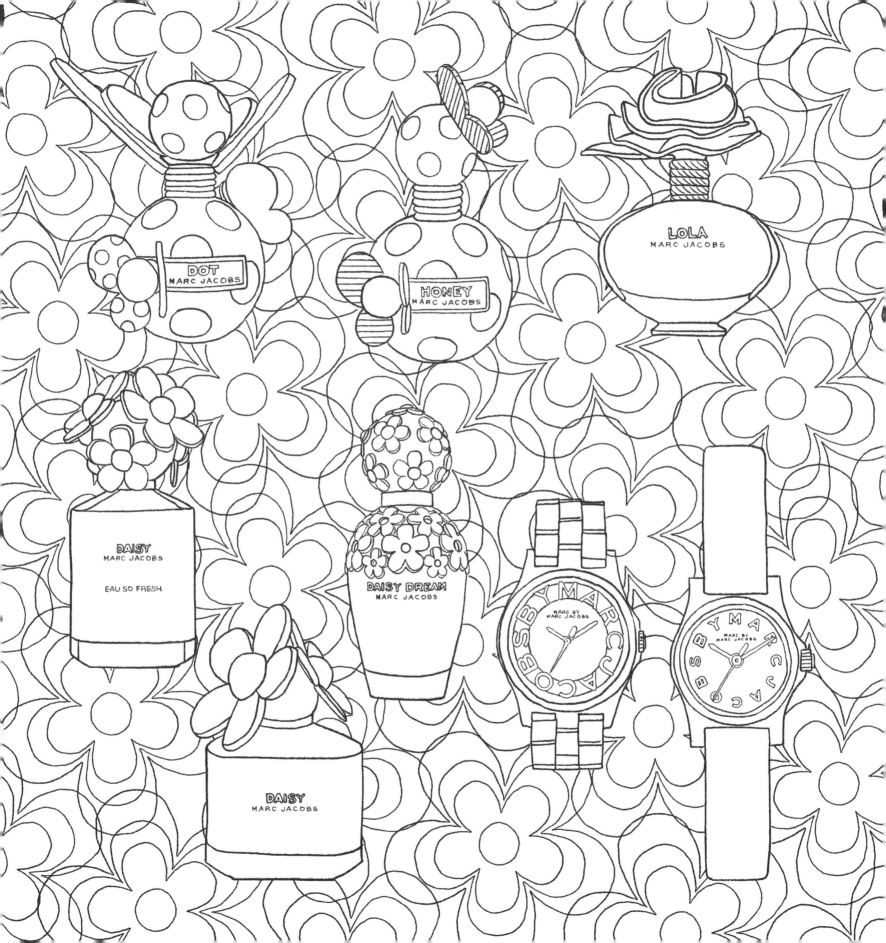

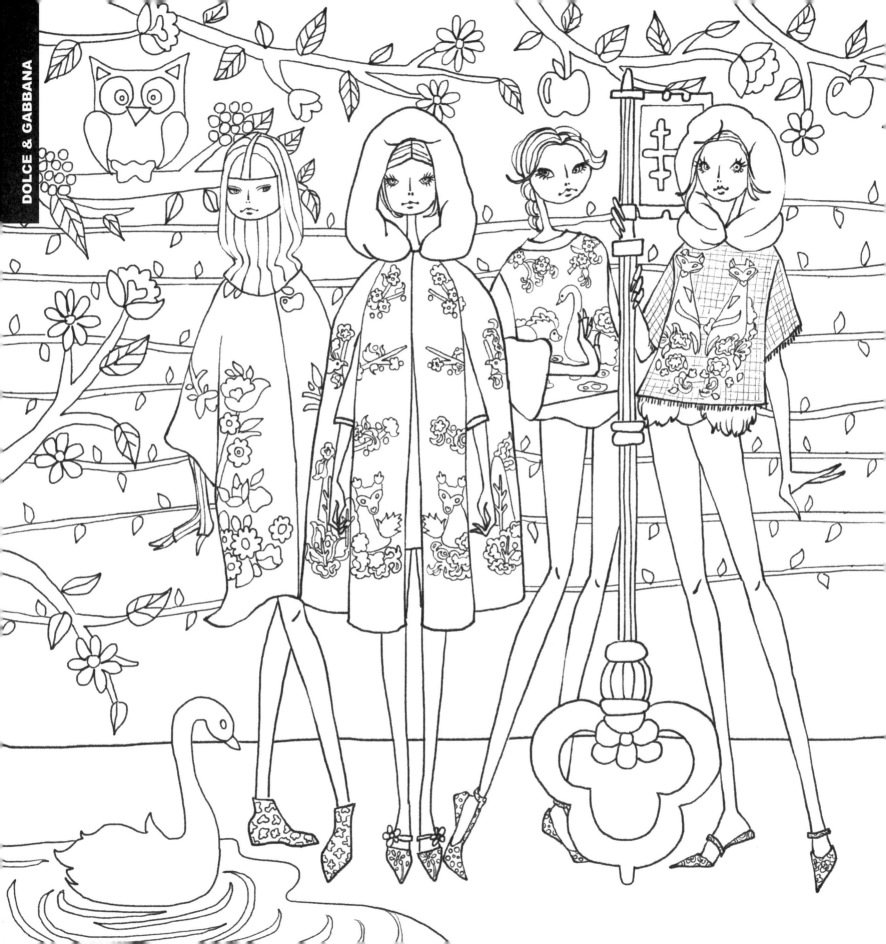

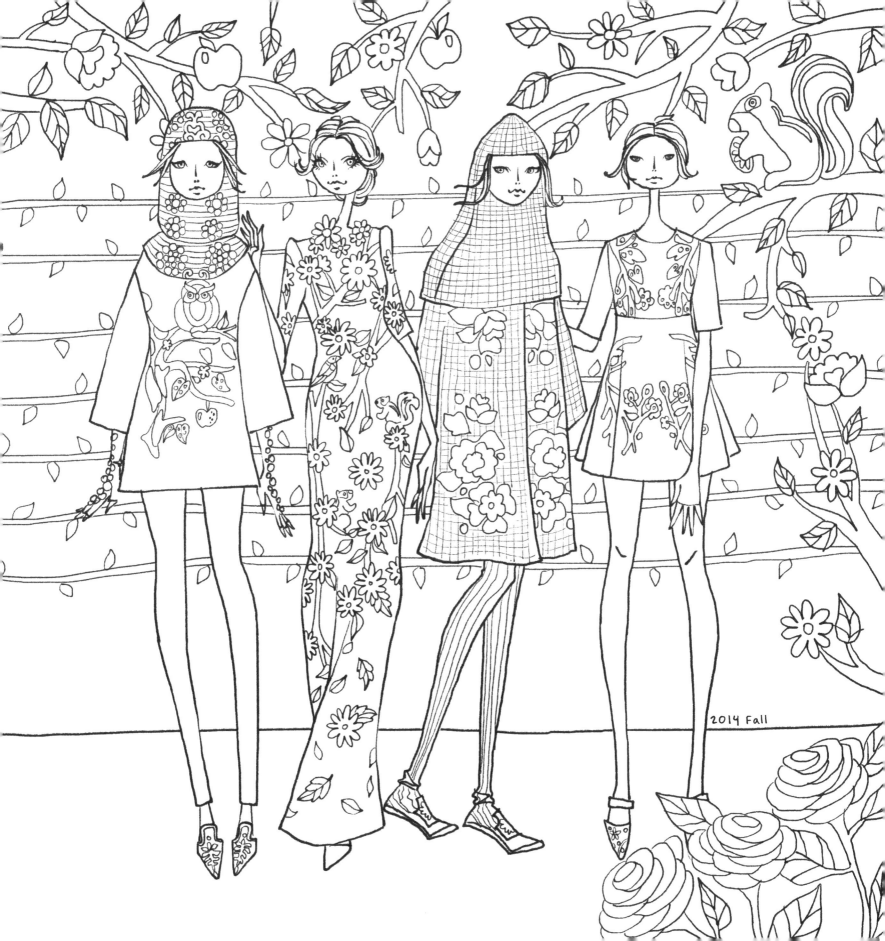

ANNA SUI

ANNA SUI
IN
WONDERLAND

2008 fall

2010 spring

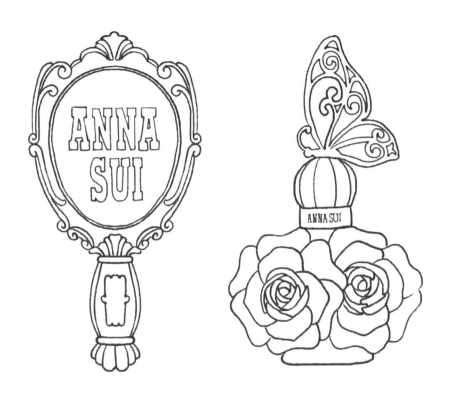

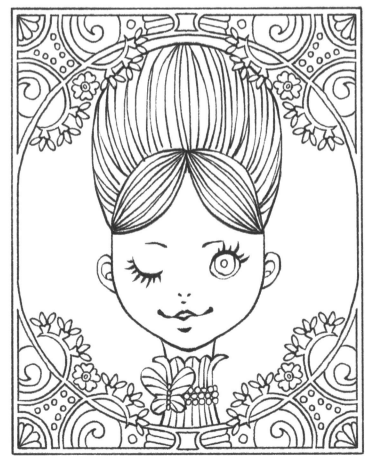

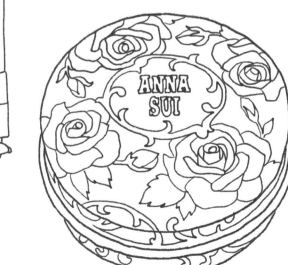

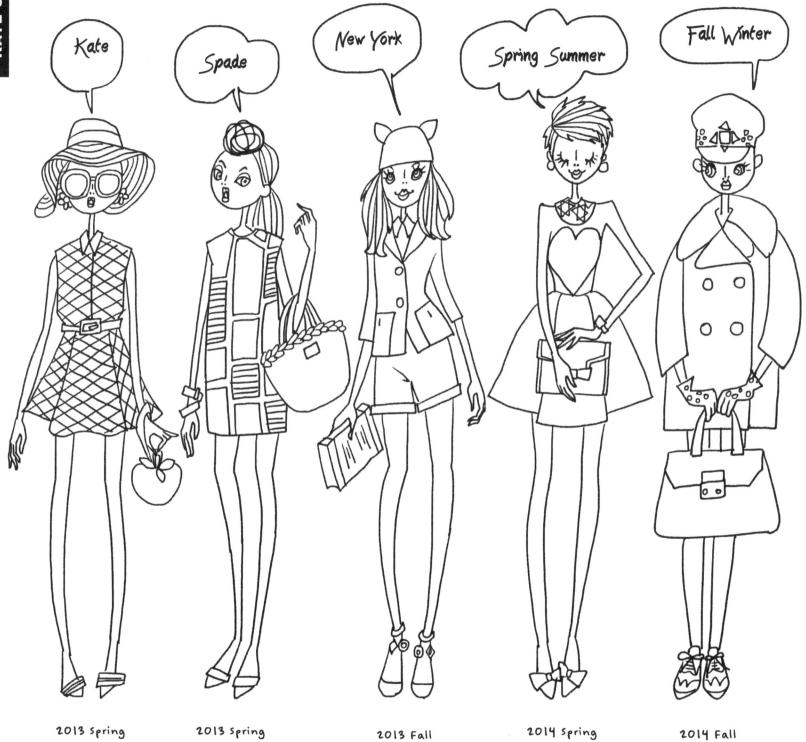

2013 Spring 2013 Spring 2013 Fall 2014 Spring 2014 Fall

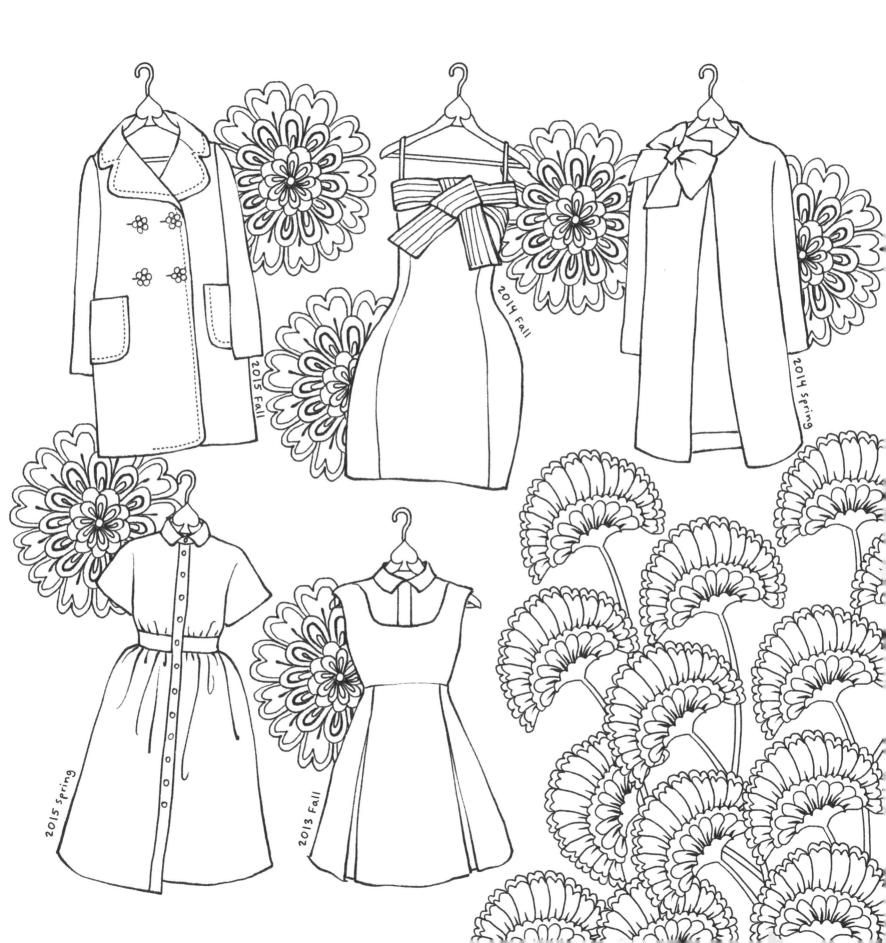

2015 Fall

2014 Fall

2014 Spring

2015 Spring

2013 Fall

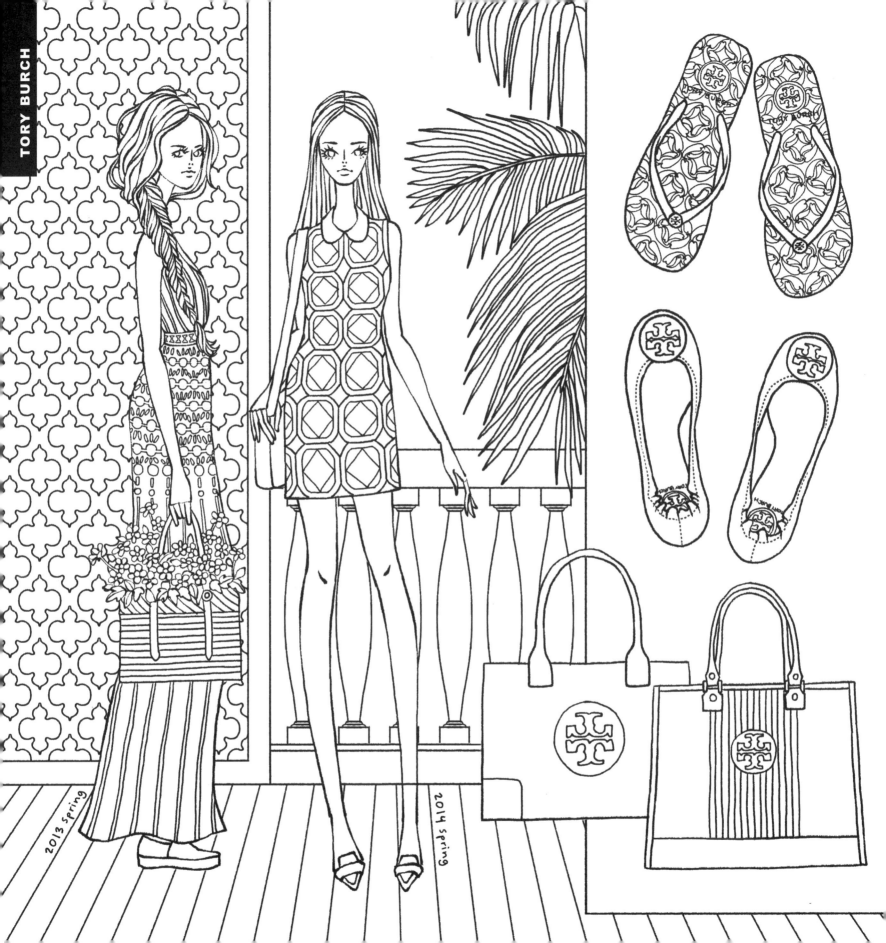

2013 spring

2014 spring

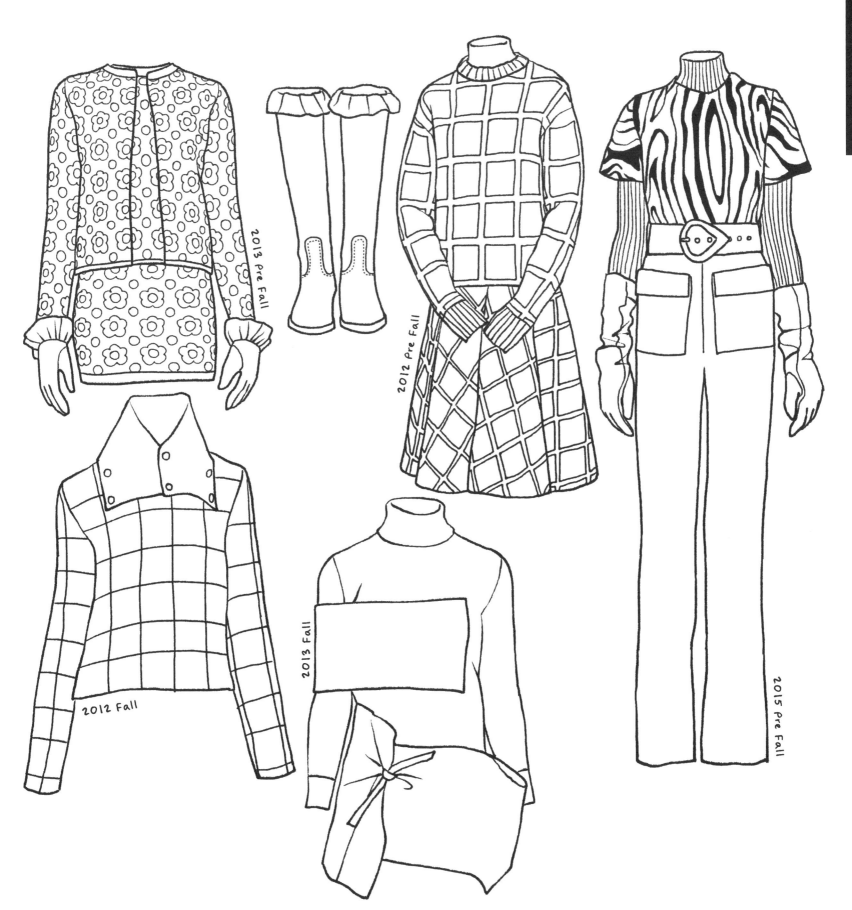

2013 Pre Fall

2012 Pre Fall

2012 Fall

2013 Fall

2015 Pre Fall

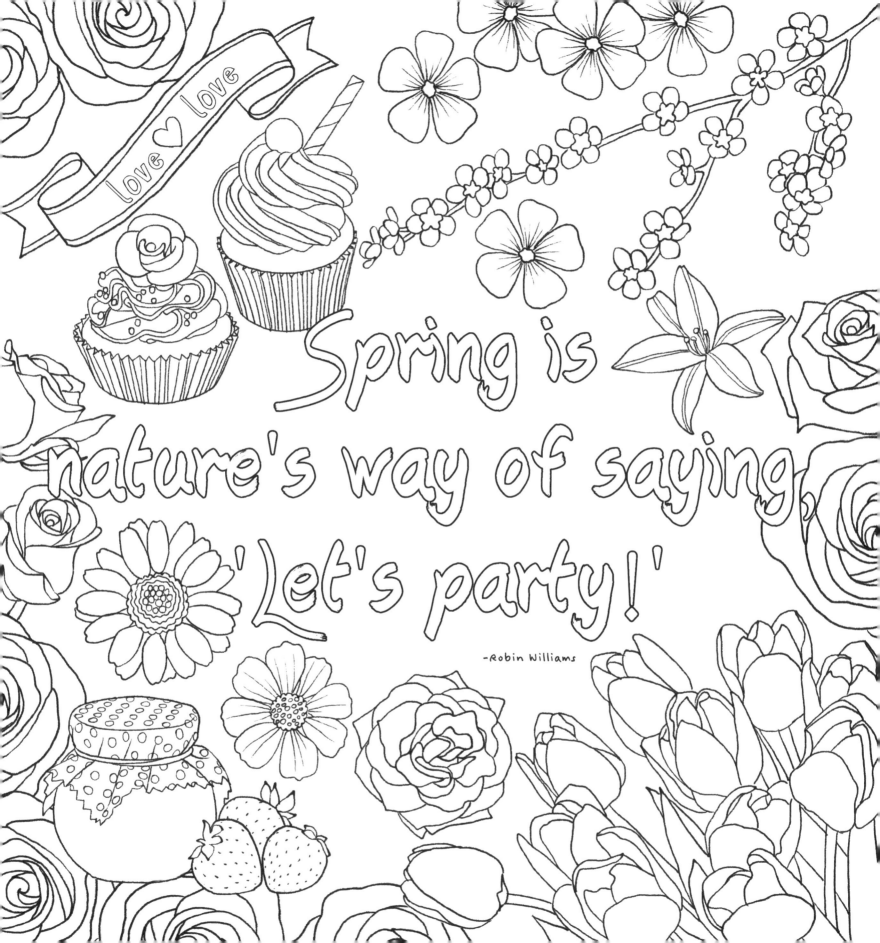

Love ♥ Love

Spring is nature's way of saying, 'Let's party!'

-Robin Williams

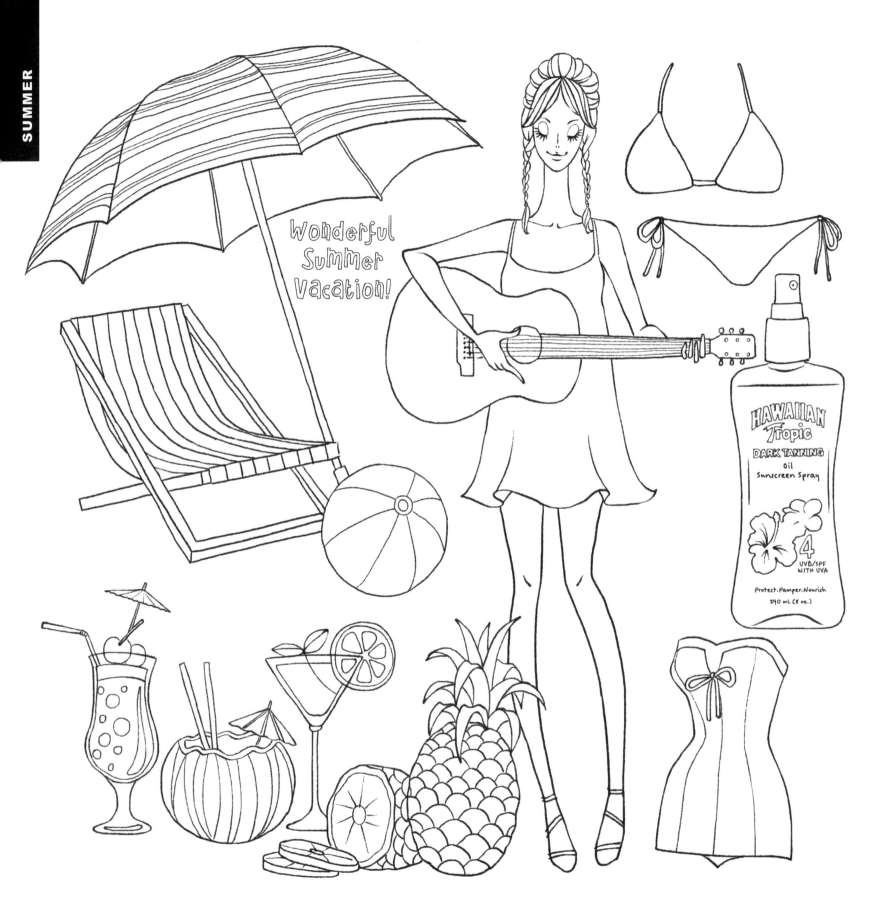

Wonderful Summer Vacation!

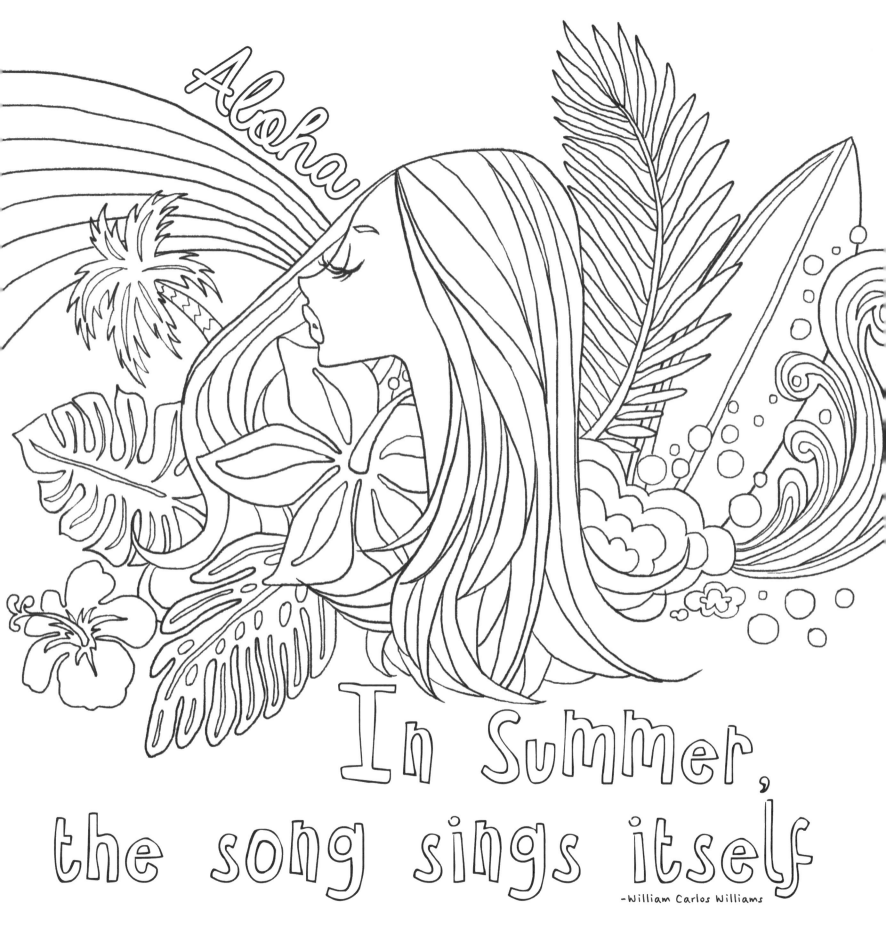

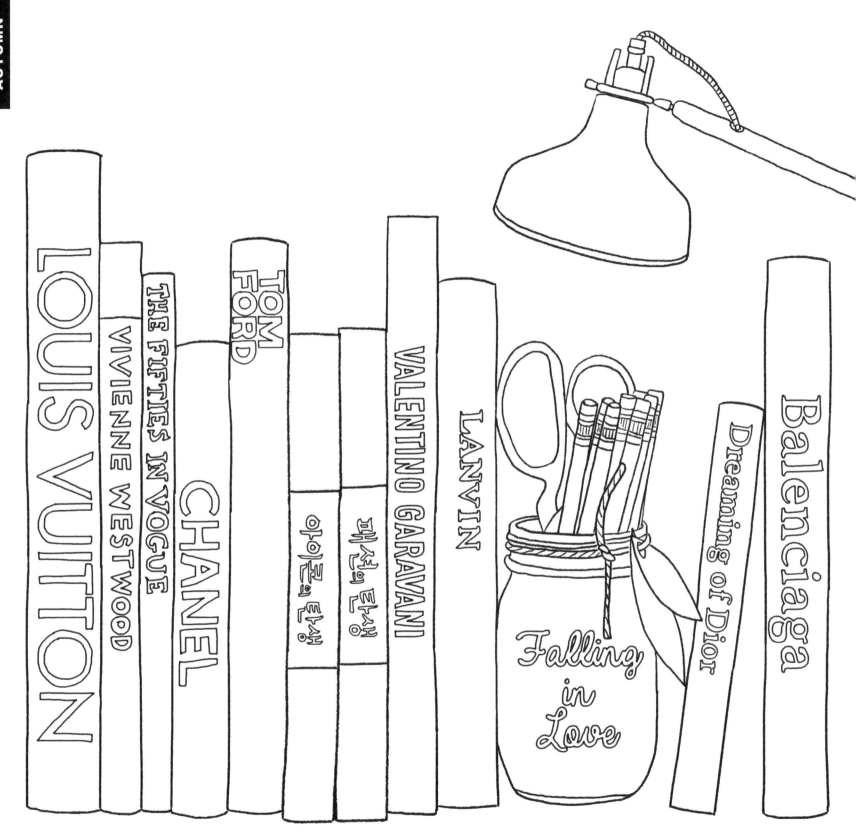

Autumn is a second spring
when every leaf is a flower
-Albert Camus

Happy Holidays

Classic Breakfast

Spaghetti with Roasted Tomatoes and Herbs

Eggs

Black bean and Quinoa burgers

It's Brunch Time

French Fries

SIR KENSINGTON'S
KETCHUP
All Natural
SPICED

Candied Blood Oranges

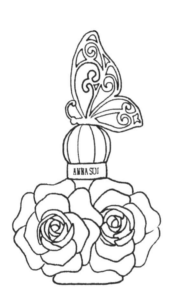

Fashion Week
London Collection

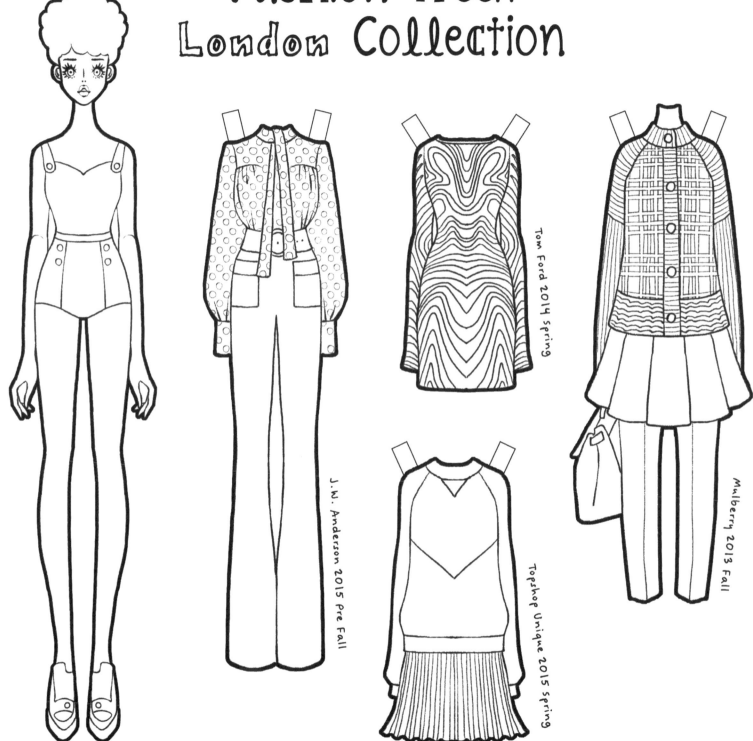

J.W. Anderson 2015 Pre Fall

Tom Ford 2014 Spring

Topshop Unique 2015 Spring

Mulberry 2013 Fall

Fashion Week
Milan Collection

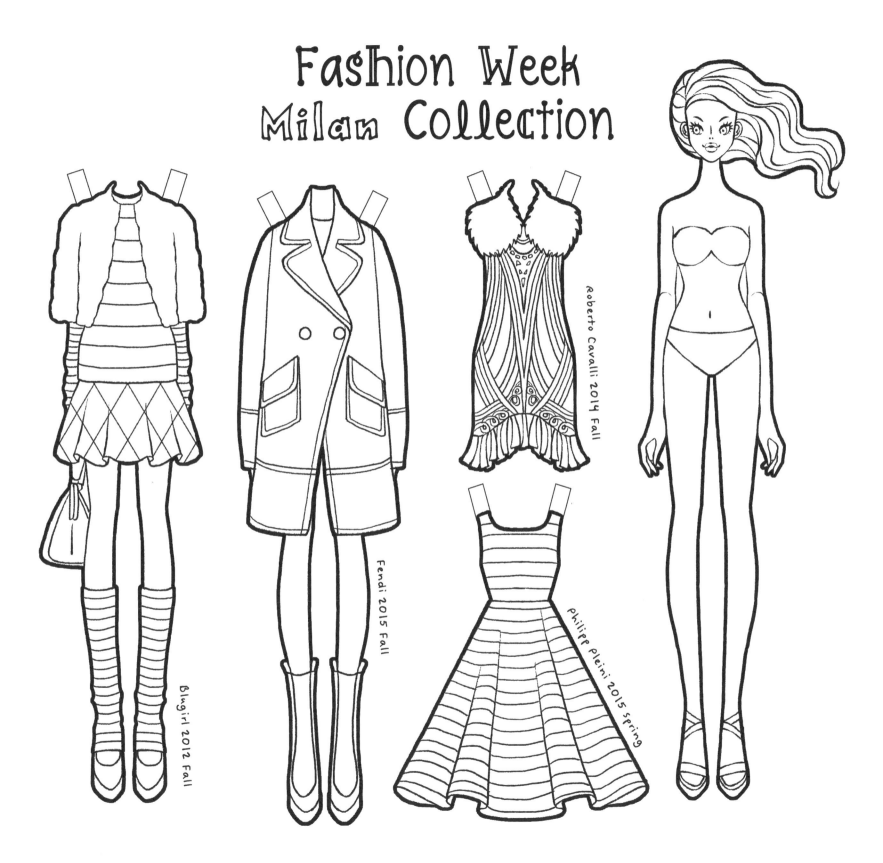

Blugirl 2012 Fall

Fendi 2015 Fall

Roberto Cavalli 2014 Fall

Philipp Pleini 2015 Spring

Fashion Week
Paris Collection

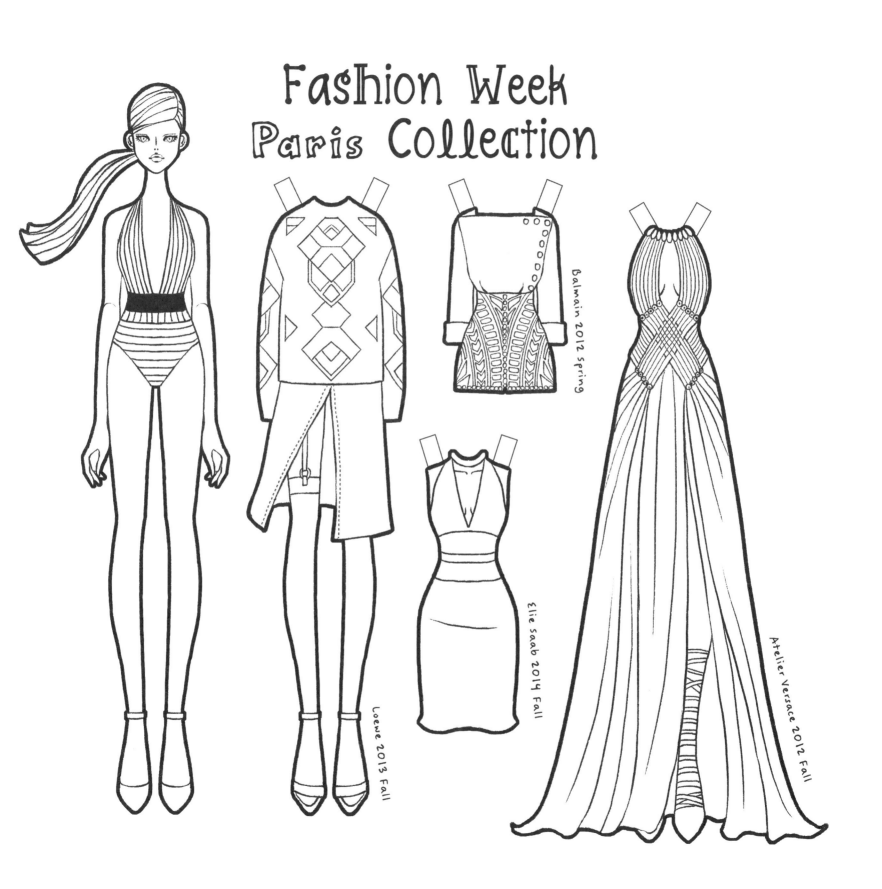

Balmain 2012 spring

Loewe 2013 Fall

Elie saab 2014 Fall

Atelier Versace 2012 Fall

Fashion Week
New York Collection

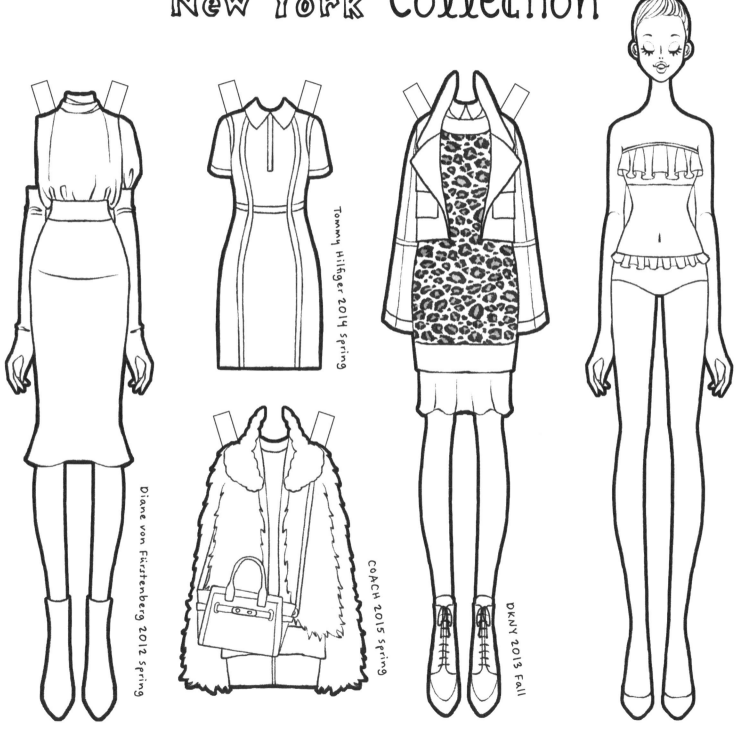

Tommy Hilfiger 2014 spring

Diane von Fürstenberg 2012 spring

COACH 2015 spring

DKNY 2013 Fall

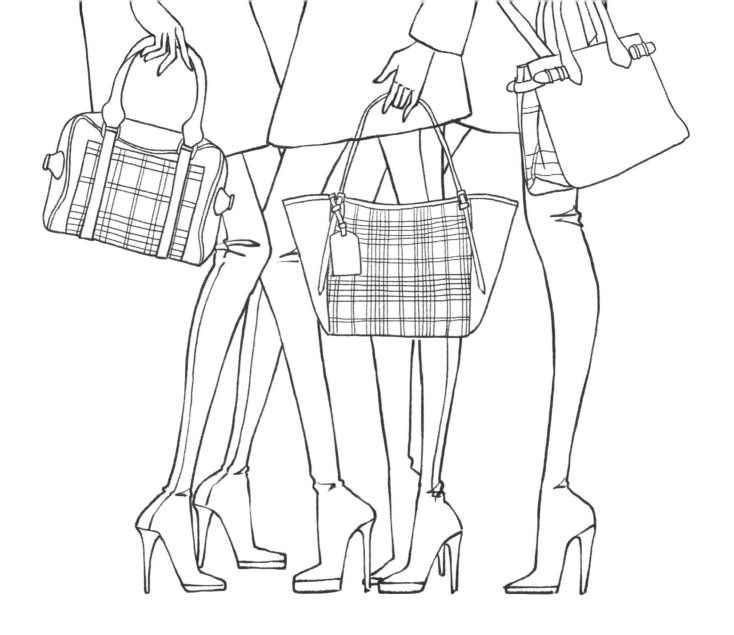

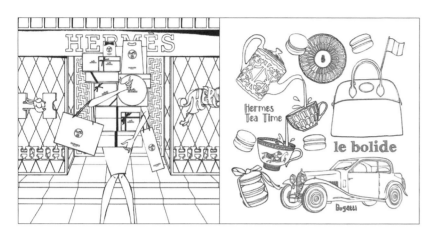
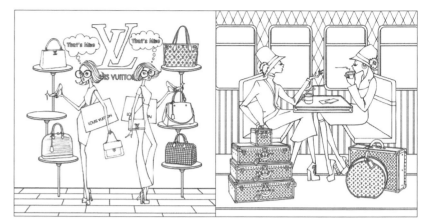
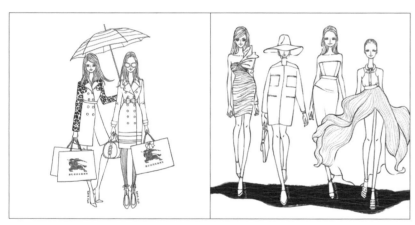
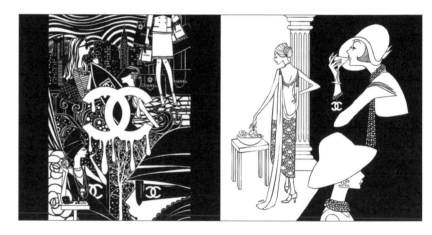
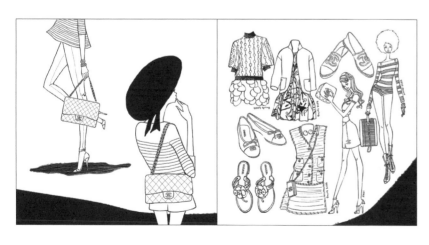
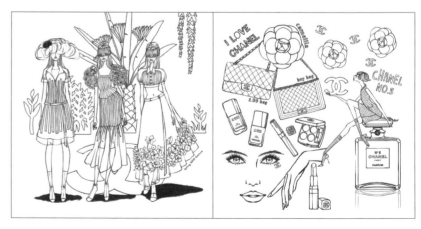

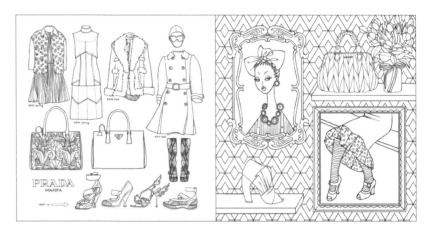

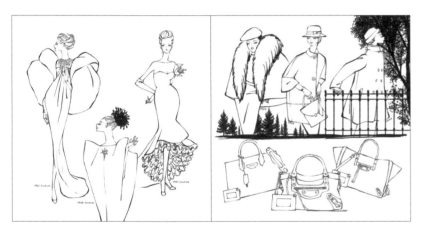

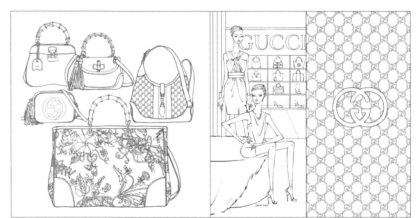

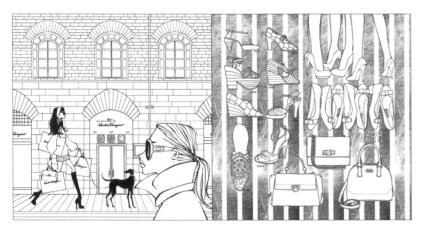

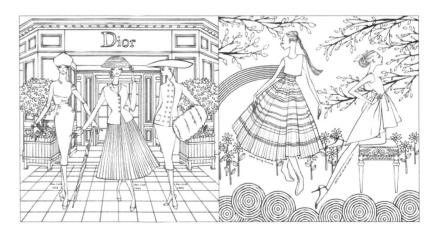

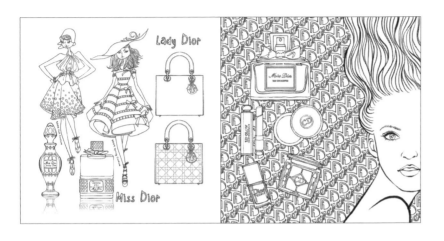

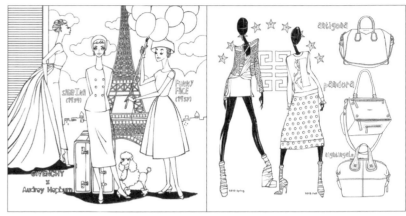

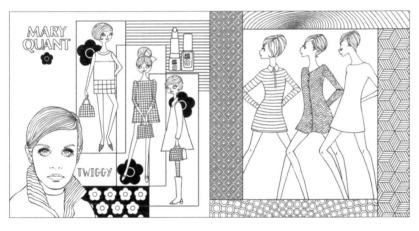

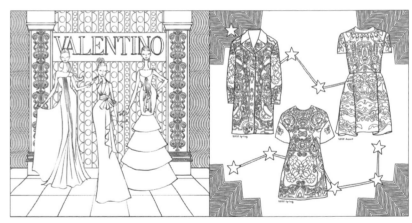

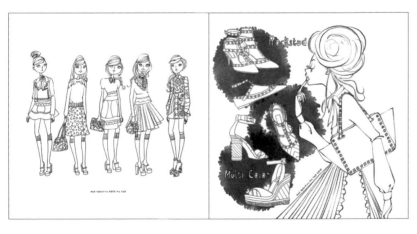

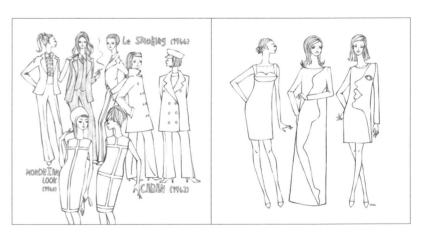

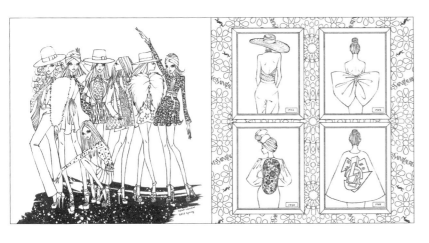

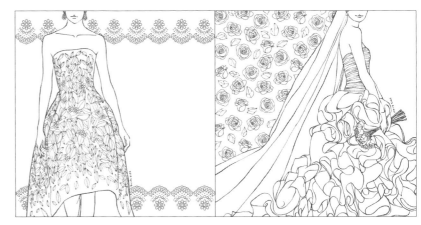

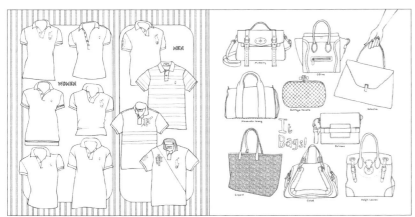

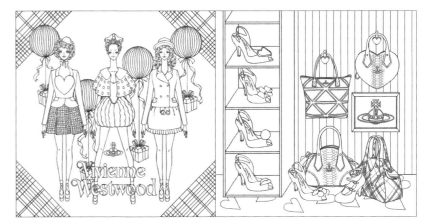

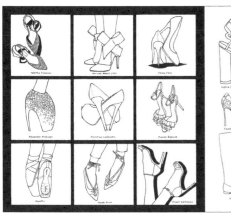

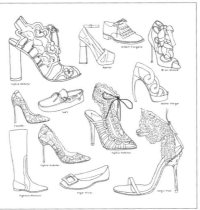

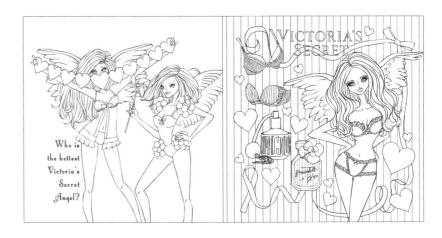

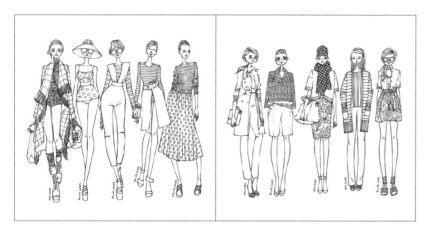

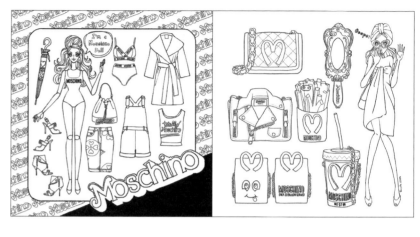

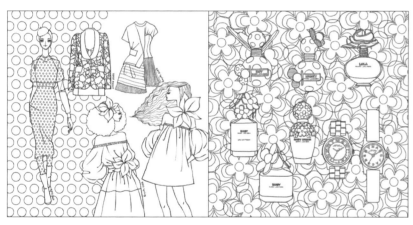

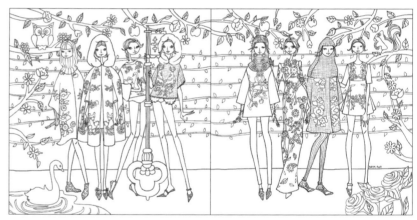

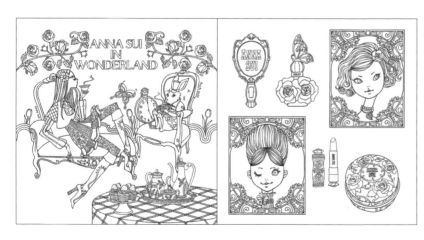

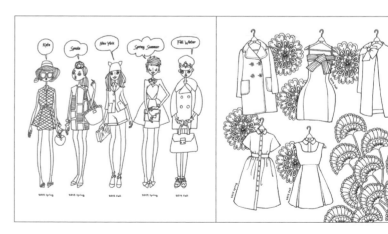

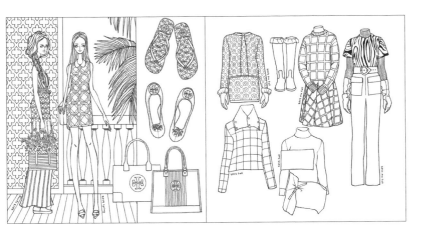

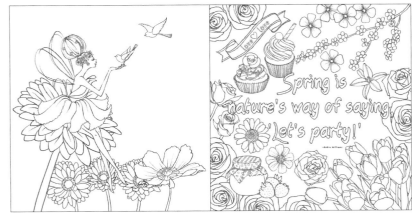

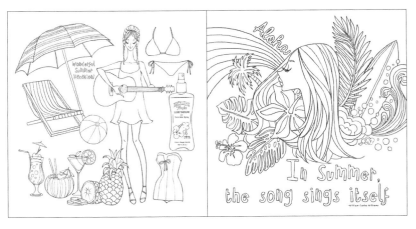

Aloha

In Summer,
the song sings itself

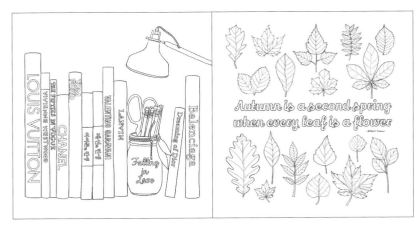

Autumn is a second spring
when every leaf is a flower

Falling in Love

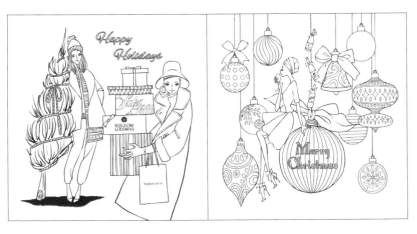

Happy Holidays

Merry Christmas

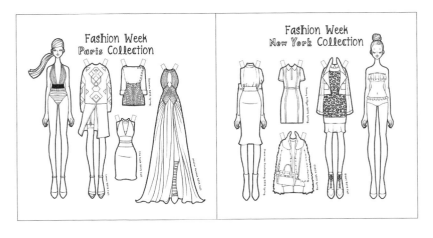

Fashion Week
Paris Collection

Fashion Week
New York Collection